Andrea Rose

THE PRE-RAPHAELITES

PHAIDON

For M.W.

Phaidon Press Limited, Littlegate House, St Ebbe's Street, Oxford

First published 1977

© 1977 by Phaidon Press Limited

ISBN 0 7148 1791 0

Printed in Great Britain by Chapel River Press, Andover, Hants.

THE PRE-RAPHAELITES

The formation of the Pre-Raphaelite Brotherhood in 1848 was the starting-point for a movement whose concerns soaked deep through the cultural fabric of Victorian life. The seven young artists and writers who founded the Brotherhood were united, primarily, in their determination to elevate the status of art from the vapidity into which it had then fallen to an expression of genuine emotional engagement. What started, however, as a movement of reform in painting against academic sterility led to an aesthetic revolution of wide-ranging implication. It effected the reassessment of the position of the creative individual within an increasingly mechanical society, and, by defining itself in all areas of aesthetic experience – from wallpaper and domestic furniture to clothes, stage production and architecture – assumed a dynamic role in the field of English art and literature way beyond the import of any of the individual paintings produced by the movement. For unlike terms such as Impressionism or Fauvism, which penetrate immediately to certain consistent stylistic features in the works produced under their rubric, the term 'Pre-Raphaelitism' does not serve usefully as a stylistic counter, but as an indicator towards a general area of sentiment in which artists as diverse as Dante Gabriel Rossetti, William Holman Hunt, Coventry Patmore, Algernon Swinburne and Simeon Solomon were working during the second half of the nineteenth century.

The direction of this sentiment was wryly located by Prince Albert, who, when discussing the position of art in his times, declared that it lay 'somewhere between religion and hygiene': in other words, between the poles of High Victorian morality (with its religious fervour for social reform) and the aesthetic doctrine of Art for Art's Sake (with its concomitant of exaggerated personal attention). Operating between these two extremes, the Pre-Raphaelites exercised a stylistic latitude that makes it difficult to see much congruity between their paintings; yet, for the brief period between 1848 and 1853, the formal association of the Pre-Raphaelite Brotherhood provided a compression chamber for the differing artistic motivations of its members, in which the inconsistencies in their working aesthetic and their naturally opposed ways of transcribing reality were momentarily annealed in a single viewpoint. This gives to many of their early compositions not only their peculiar flavour, but also their concentration, in which the essence of the myriad aesthetic impulses emanating from the Brotherhood's doctrines is preserved. The history of Pre-Raphaelitism traces the dispersal of that essence, which is given fresh emphasis as it emerges in the paintings produced by the Pre-Raphaelites and their followers long after the demise of the original Brotherhood.

Six of the founding members of the Brotherhood were students from the Royal Academy schools, though only William Holman Hunt (1827–1910), John Everett Millais (1829–96) and Dante Gabriel Rossetti (1828–82) are of serious note as painters. Together one evening these three students looked through a volume of engravings by Carlo Lasinio after the fourteenth-century frescoes of the Campo Santo in Pisa, and found in these works a focusing matrix into which they could pour their as yet formless aspirations for a regeneration of English art. They decided to bond their shared enthusiasm for these works by forming a secret fraternity, the Pre-Raphaelite Brotherhood, into whose ranks they admitted James Collinson (1825–81), a painter whose Tractarian sympathies are more interesting for the history of the movement than are his canvases, for their High Church flavour pervades much Pre-Raphaelite painting; Frederick George Stephens (1828–1907), whose article for *The Germ* (the magazine published by the Pre-Raphaelites from January to April 1850) on 'The Purpose and Tendency of Early Italian Art' is a clear pronouncement of Pre-Raphaelite belief; and Thomas Woolner (1825–92), a sculptor of

nominal talent. Rossetti's brother, William Michael Rossetti (1829–1919), was the only member of the Brotherhood without formal artistic pretensions, but he served the movement indefatigably as its secretary and historian. Though the Brotherhood never extended its membership to include the many artists sympathetic to its aims, painters such as Ford Madox Brown (1821–93), Arthur Hughes (1832–1915), and Charles Allston Collins (1828–73) became identified early on as Pre-Raphaelites, and in fact it was Collins's *Convent Thoughts* (Plate 8) that was first branded as exhibiting the 'paltry affection for middle age ecclesiasticism' with which the Pre-Raphaelites as a body were subsequently charged.

The constitution of the Brotherhood was clearly less important than the fact that it should number seven, a cipher to which a certain mysticism has always attached. Given the underlying moral tenor of the first Pre-Raphaelites, one wonders what conscious relationship they were asserting to the Seven Sleepers, those early Christians who fell asleep in a cave where they had fled to escape the Decian persecution and who woke two hundred years later when the Roman Empire was Christian. Certainly, in their self-styled designation as a Brotherhood, and in the similarity of their aims to those of the Nazarenes, a group of German Catholic artists who had adopted a monastic existence in sympathy with the spirit of early Christianity, the Pre-Raphaelites were consciously associating themselves with the supposedly less mannered communities of an earlier period. Certainly, it was characteristic of the Pre-Raphaelites to employ images which cut through the accumulated layers of cultural association to activate tremors of meaning beneath the surface of their works. Certainly, too, they undertook their first paintings as Pre-Raphaelites in a spirit of martyrdom, for the jerky forms of Millais's *Christ in the House of his Parents* (Plate 5), flaunting in the face of conventional draughtsmanship, and the virulent colour of Hunt's *Valentine Rescuing Sylvia from Proteus* (Plate 10), grazing all accepted standards of subtlety and good taste, spell heresy to academic convention, and combine to make the experience of such paintings a painful one. It was John Ruskin, the great apologist of the movement, who pointed out the necessity for this approach in his Edinburgh lectures of 1853:

> You perceive that the principal resistance they have to make is to that spurious beauty whose attractiveness had tempted men to forget, or to despise, the more noble quality of sincerity: and in order at once to put them beyond the power of temptation from this beauty, they are, as a body, characterized by a total absence of sensibility to the ordinary and popular forms of artistic gracefulness; while, to all that still lower kind of prettiness which appears in our lower art . . the Pre-Raphaelites are not only dead, but they regard it with a contempt and aversion approaching to disgust. This character is absolutely necessary to them in the present time; but it, of course, occasionally renders their work comparatively unpleasing. As the school becomes less aggressive, and more authoritative . . this great ground of offence will be removed.

The fact that Lasinio's engravings, themselves reproductions of original fourteenth-century frescoes, should have proved the catalyst for a movement whose sole enunciated principle was that of 'absolute and uncompromising truth in all that it does, obtained by working everything, down to the most minute detail, from nature, and from nature only', emphasizes the sort of duality in which Pre-Raphaelitism abounds. What excited the Pre-Raphaelites in these prints were the formal qualities of incisive outline, of sharp, controlled contours circumscribing flat and unshaded areas, which they felt to be a direct correlative of moral stringency and probity. These qualities represented a positive challenge to all that they found contemptible in contemporary academic practice, still bound, as it was, to the aesthetic precepts laid down by Sir Joshua Reynolds, the first president of the Royal Academy, in his *Discourses on Art*. Reynolds's admiration for High Renaissance painting, which first flowered in Raphael and reached its full bloom in

the seventeenth-century schools of Northern Italy, had fostered a tame school of British painters, well versed in the handling of dramatic chiaroscuro, pyramidal composition, histrionic gesture, loose, open brushwork and Italianate landscape, but totally divorced from the mental processes which had governed the production of the 'Old Masters' whose style they emulated. The precision and keenness of fourteenth-century art, as the Pre-Raphaelites saw it mirrored in the Campo Santo frescoes, cut cleanly through the rhetoric and vapidity of this tradition, and recalled the diatribes of William Blake, whom Rossetti greatly admired, against the lax handling of form found in the work of Rembrandt, Rubens and Reynolds. 'Filth' was Blake's unequivocal term for it; and the purgative weapon he recommended was 'the wiry line of rectitude'.

The Pre-Raphaelites saw in the art that pre-dated Raphael (hence the derivation of their name) not only a style more direct, and therefore more realistic, than that of their own contemporaries, but also a natural humility in its simple delineation of objects that was imbued with genuine religious feeling. Two prominent features of Pre-Raphaelite art that emerge at the outset of the movement, and which appear superficially as irreconcilable tensions in their work – a romantic medievalism and a positivist, almost forensic concentration on natural detail – are thus really opposite sides of the same coin. The success of medieval art lay in its 'natural principles', which, as F. G. Stephens explained, 'it is as useless to attempt to elevate as it is to endeavour to match the works of God by those of man'. Any deviation from the correct outline of objective data would therefore amount to a vain presumption on the part of the artist. To be as the quattrocento artist was, humble before nature and faithful to the description of its details, was to recapture a reverence that had long since disappeared from academic painting. Originally, therefore, it was not in an attempt to flee from the hideousness of contemporary reality that the Pre-Raphaelites developed the taste for medieval form, nor was it an attempt to substitute 'unrealities for realities', but a conscientious effort to draw closer to those forms in which an objective rendering of the natural world had carried a genuine metaphysical reality. That they failed (and it must be admitted that this is the case), and that their original aims later became the excuse to see painting as 'a beautiful, romantic dream of something that never was', as Burne-Jones described his own work, underlines the incompleteness of the Pre-Raphaelites' understanding of history. For the underlying experience of life in the medieval period was sacramental: every aspect of physical existence, from the flowers and beasts of the field to the stones and glass of the great churches and cathedrals, was seen as a formal embodiment of the divine workings of God on earth. The concrete substance of everyday living was matched always to a symbolic register, so that the resulting imprint, transmitted through their works of art, communicated a sense of a total reality – expressed as a fusion of object, symbol and idea – which had a comprehensiveness denied to the mechanistic world of the nineteenth century, where spirit and matter were irrevocably split apart. The Protestant, Victorian world of the Pre-Raphaelites, which had long abdicated all claims to a sacramental conception of life, but which was now suffering the breakdown of its formal religious structure, could not possibly accommodate itself to the vision of wholeness between everyday fact and implicit values by which the medieval artist celebrated the reality of existence. Thus, inevitably, the forms and allegories of the medieval period were, for the nineteenth-century artist, a matter of historicism and mythology rather than of genuine experience, productive, at best, of viable archaeological reconstruction, and at worst, of the 'Wardour Street medievalism' of fancy dress. It was Ruskin who pointed out, in *The Queen of the Air*, that mythologies are most vital during the period which believes in them; but it was in France, rather than in England, that the major new symbols pertinent to contemporary reality – the black frock-coats, the tall bowlers, the boulevards and the race-tracks – were being permanently established as the stuff of contemporary mythology. Reality, as Carlyle affirmed, is 'the only genuine Romance for grown persons', and much

of the Pre-Raphaelite transcription of reality was an indication not of their insincerity, but of their immaturity.

If the medievalizing tendencies of Pre-Raphaelite art denote immaturity on the one side, then the other side of the coin, the painstaking elaboration of natural detail, carries an equally fallacious assumption, namely, that realism in painting exists in direct relation to the degree of photographic veracity achieved. Nothing could be less realistic than the impression of instantaneity which John Brett has tried to crystallize in *The Stonebreaker* (Plate 21) by painting the labourer and his dog caught poised over their respective targets. Doubtless a frolicking dog appears like this at the specific instant that he pounces on his master's checked cloth cap, and doubtless too the worker appears like this as he is about to bring down his pick on the stones before him; but the meticulous method of painting this scene, as if every detail had been closely examined under a microscope, suggests an enormous expenditure of time on the part of the artist – the very opposite of which is experienced by the worker and his dog in their momentary positions of suspended action. The technique is thus a serious impediment to the realism of the work, and one has only to consider the success of the Impressionists in France in this domain, where form is perfectly soldered to content, to understand the permanence of the revolution they wrought on European aesthetics as opposed to the fragmented influence of the Pre-Raphaelites.

The Brotherhood's call for sincerity, for realism, for truth, was not simply a youthful tirade against academic sterility; it was, at bottom, a *cri-de-coeur* against the most deadening of all attitudes that pervaded the Victorian mentality: not mendacity, as Carlyle argued in *Latter-Day Pamphlets,* not even falsism, as George Henry Lewes proclaimed in *Realism in Art,* but indifference. It was an indifference bred by urban industrialization, with its leaden machinery, its greyness and its materialism; an indifference that suffered the despoiling of the countryside, the erection of 'dark Satanic mills', and the untenable conditions of labour and slum life, with their attendant horrors of prostitution and illegitimacy.

One of the ways in which the Pre-Raphaelites sought to hit out against this emotional numbness was by trying to forge a new iconography relevant to the times in which they lived and to the great social issues of the day. Moral and social responsibility is the subject of Ford Madox Brown's painting of 1857, '*Take your Son, Sir!*' (Plate 18). The wronged woman courageously exhibits her baby from the folds of her womb-like clothing to the spectator, thus placing the responsibility on the seducer (whose image is reflected in the round, halo-forming mirror behind her) and on society as a whole. The question of the legal responsibility and custody of children had already been the focus of heated public discussion two years earlier, when Lady Caroline Norton had raised the subject in her impassioned 'Letter to the Queen', published in *The Times.* In 1839, she had been instrumental in getting an amendment to the Custody of Infants Act; by 1857, the date of Brown's work, her voice had successfully aided the passage of a new Divorce Bill through Parliament which, for the first time, granted separated women power of contract and of suing in civil proceedings. The uncompromising and iconic treatment of this theme by Brown has few parallels in the painting of the period, and one can only speculate as to the reasons why the picture was left unfinished.

Holman Hunt treated the theme of prostitution in *The Awakening Conscience* (Tate Gallery) and in *Claudio and Isabella* (Plate 3). This last work shows, perhaps disappointingly to modern eyes, the orthodoxy of Hunt's views on contemporary morality. Its subject, taken from *Measure for Measure,* is the moment when Claudio has entreated his sister Isabella to sacrifice her virginity to his captor, so that his own life may be spared. The drama of the scene is somewhat mitigated by the blankness on Isabella's features, and her tacit refusal may appear as a lost opportunity to question contemporary ethical values. Yet one cannot afford to be totally dismissive of this puritanism on the part of Hunt. For in his day, a woman's assertion of her chastity was one of the few means by

which she could affirm her integrity as an individual in a society where married women were legally classified with 'criminals, idiots and minors'. To remain pure, therefore, has a political significance, in that it is a conscious rejection of subjection and exploitation by the 'gentleman' classes and a democratic stand for the essential humanity of womanhood, striving to survive independently of its usefulness to men.

One of the major political issues of the day was that of labour in an increasingly industrialized society, and this provides the theme for both John Brett's and Henry Wallis's paintings of *The Stonebreaker* (Plates 21 and 23), for William Bell Scott's *Iron and Coal* (Plate 22), and for Ford Madox Brown's paintings of *Work* (Plate 20) and *The Last of England* (Plate 19). The question of proletarian rights had been brought to the forefront by the Chartist demonstrations of 1848, and the face of the labourer, previously ignored as a subject worthy of depiction in art, was looked upon with sympathy and interest by the Pre-Raphaelites. 'It appeared to me', wrote Ford Madox Brown of the English navvy, 'that he was at least as worthy of the powers of an English painter as the fisherman of the Adriatic, the peasant of the Campagna, or the Neapolitan lazzarone.' The stonebreaker, at the very nadir of the employment pile, has, according to the inscription by Carlyle appended to Wallis's painting, literally died at work. The weakness of the picture is not in its painting, which is tender and exquisite in its treatment of the landscape, but in the fact that the 'message', ostensibly the ignominy and degradation of such meaningless labour, is dissolved in one's wonder at the beauty of the natural setting. Brett's stonebreaker seems not to be unduly burdened by his social role either, and in the azure horizons of this work there is something of the naïve idealism which informed Ruskin's back-to-the-soil campaign of the early 1870s, when he armed his undergraduates with picks and shovels and led them out to the Oxford roads, to give them the genuine experience of manual labour.

Ford Madox Brown's *Work* (Plate 20) argues the case of labour far more cogently. Enormously complex, in its very particularity and in its inability to focus clearly the different perspectives of the problem into a single, organised unit, *Work* is a true pictorial amalgam of a society that was passionately debating the newly evolving relationships between democracy and freedom, liberty and justice, within an industrial context. To the right of the picture, leaning against the railings, stand 'the brainworkers', personified by Thomas Carlyle and Frederick Denison Maurice (the leader of the Christian Socialist movement). Their work is 'the cause of well-ordained work and happiness in others'; they are not, however, positioned hierarchically in the composition, but latitudinally, so that they share the same level as the manual workers in the centre, and the 'ragged wretch' on the left, 'who has never been *taught to work*', and whose frustrated energies are converted into an expression of society's fears and anxieties. It is the idle rich, represented by the couple on horseback (the pastrycook below them symbolizing conspicuous waste), who are on a different level from those who work and those who wish to work; but the road is barred between the two levels, all psychic progress blocked by the barriers of wealth and privilege. The theme of democracy is supported by the egalitarian treatment of the details, from the posters on the wall, with their announcements for the Working Men's College (of which Maurice was a founding father) and the Euston Road Boys' Home, to the sandwich-men in the distance of Hampstead's Heath Street, walking their election messages of 'Bobus for Middlesex, Vote for Bobus'. The irony behind this painting is that while it successfully develops the new iconography of the working man, this development comes at the moment when the machine has already started to take over the very strength extolled in Brown's navvies, and this forces one to recognize again the circumscribed view that the Pre-Raphaelites had of history and, in this case, the history of their own period.

Carlyle's presence in this picture testifies to the vatic role the Pre-Raphaelites assumed in many of their canvases, as prophets talking to their age about the dire conditions of its

soul. And as in Carlyle's work, the manner of utterance is that of minute and atomistic research presented in a vivid and coherent image. This is most striking in Brown's *Last of England* (Plate 19). Behind this picture of a middle-class couple leaving the shores of England to find work and justice in a new society is the voice of Carlyle's *Past and Present,* describing the disorder of contemporary industrial society, held together not by any sense of moral justice or responsibility between employer and worker, but solely by the cash nexus. One of the remedies advocated by Carlyle was emigration, and this, coupled with the mass emigration waves of 1848–52 and, more specifically, the departure of one of the Brotherhood, Thomas Woolner, to the gold-fields of Australia, was the inspiration behind this painting. Every detail, from the threaded cabbages swinging from the stern (to indicate a lengthy voyage) to the chequered lining of the man's coat flapping upwards from his knees, is scrupulously observed, as are the details of *Work*; here, however, they are not organized in the simple, additive manner of *Work*, but act as a foil around the intensity of the seated couple, so that they support and complement, rather than dissipate, the central image. And where the figures in *Work* symbolize general categories of labour (the navvy representing manual labour, the philosophers intellectual labour), the two central characters of *The Last of England* (which are portraits of the artist and his wife) stand, *a priori*, for nothing other than themselves. Their very contemporaneity denies them the attributes of timeless allegory. Yet, by searching for reality only within the facts of contemporary existence, this painting achieves a realism far beyond that of such academic attempts to portray eternal truths as G. F. Watts's *Love and Death* (Tate Gallery), or Walter Crane's *The Roll of Fate* (Private Collection), which, for all their employment of classical allegory, smack far more insistently of the age of Mr Podsnap and Mr Gradgrind than Brown's factual rendering of Mr and Mrs Brown off Folkestone Harbour.

One of the means by which *The Last of England* achieves its success is its brilliance of light and colour, which, while giving definition to the details of the scene, creates the clarity and cohesion that knit the painting into a satisfying whole. The handling of light and colour in this manner was the result of the Pre-Raphaelites' interest in the early techniques of fresco painting, techniques exemplified in the Campo Santo murals and discussed in contemporary publications such as Charles Eastlake's *Materials for a History of Oil Painting* (1847). Such publications not only provided the Pre-Raphaelites with a manual on the craft of fresco painting, but confirm that their historical interests were in line with the major enthusiasms of contemporary scholarship, and were not simply a matter of the escapism with which they have often been charged.

Academic practice had perpetuated the painting of generally sombre canvases in the belief that this was the formula for much 'Old Master' work (though it was largely due to the discoloured varnishes on the older canvases) and also in emulation of the dramatic effects of chiaroscuro. With the adoption of fresco techniques in their easel paintings, and specifically the laying of a wet white ground before the application of the coloured surface of the composition, the Pre-Raphaelites achieved a startling vibrancy in their works, the full effects of which can be gauged in the vitreous, effulgent surface of Hunt's *Valentine Rescuing Sylvia from Proteus* (Plate 10). Gone are the bituminized sobrieties of William Etty and Francis Grant, now replaced by a strident illumination which sorely vexed the contemporary public. This was the point, however, 'to touch the Philistine on the raw', as Ford Madox Brown put it, and in this particular – the use of tart, uncompromising colour – Pre-Raphaelite aims were perfectly attuned to their technique.

One 'Philistine' obviously 'touched to the raw' was Charles Dickens. At the Royal Academy Exhibition of 1850 he saw Millais's *Christ in the House of his Parents* (Plate 5) and gave it the following notice in his weekly, *Household Words:*

You behold the interior of a carpenter's shop . . . In the foreground . . . is a hideous, wry-necked, blubbering, red-headed boy, in a bed-gown, who appears to have received a

probe in the hand, from the stick of another boy with whom he has been playing in an adjacent gutter, and to be holding it up for the contemplation of a kneeling woman so hideous in her ugliness, that (supposing it were possible for any human creature to exist for a moment with that dislocated throat) she would stand out from the rest of the company as a Monster, in the vilest cabaret in France, or the lowest ginshop in England.

In one sense, such a reaction roundly repudiates Cardinal Newman's contemporary lament that 'it is not at all easy to wind up an Englishman to a dogmatic level'. In another sense, though, such invective does emphasize that the prime aim of early Pre-Raphaelite painting was that of an art of engagement; the fact that the infelicities of style, and the false assumptions upon which that style was based, were not, in the long run, productive of a happy and creative marriage between the artist and his public is apparent in the increasing isolation of art from reality towards the 1860s, with the renunciation of social and moral relevance in Art; as William Morris wrote in *The Earthly Paradise*: 'Forget six counties overhung with smoke/Forget the snorting steam and piston stroke/And dream of London, small and white and clean.' But that it did wrest an engaged response, albeit negative in the case of Dickens, is to be counted among its first achievements.

The shock that Dickens felt is perhaps better understood in the context of the changing aesthetics of the mid-nineteenth century, which demanded an adjustment of the classical concepts of beauty, handed down from the time of Raphael, to a relativistic view of beauty more appropriate to a democratized world. Dickens loathed the plebeian awkwardness of Millais's figures because they suggested no reference to the classical and idealized figures who had, historically, taken the pictorial roles of the Holy Family. But as Delacroix pointed out, 'The beautiful is everywhere . . and each man not only sees it, but absolutely must render it in his own way.' This relativistic approach to beauty was one of the innovations of English Romantic poetry; of Wordsworth, who chose the objects of 'humble and rustic life . . . because in that condition, the essential passions of the heart find a better soil in which they can attain their maturity'; and of Keats, whose famous words from *Ode on a Grecian Urn*, 'Beauty is truth, truth beauty', take on a new importance in the light of Pre-Raphaelite doctrine. This relativism, however, had hardly communicated itself to painting. Only Constable, perhaps, who wrote that 'my limited and abstracted view is to be found under every hedge', had assimilated this approach in his work, but he lay outside the mainstream of English academic painting. For the Pre-Raphaelites, it assumed the character of a radical innovation, and it helps to establish their position, historically, along the descending line of the Romantic movement.

The reference to Keats draws in another salient characteristic of Pre-Raphaelite art: its literariness. The use of literary themes can be traced back to the attempt to infuse art with a greater emotional content, to give to it the power with which the great literature of the world has always spoken of essential truths. In *Modern Painters I* (1843), Ruskin had adumbrated this point, and had urged the incorporation of 'significant ideas' into art: 'Painting, or art generally, as such, with all its technicalities, difficulties, and particular ends, is nothing but a noble and expressive language, invaluable as the vehicle of thought, but by itself nothing.' This view of painting, achieving richness in proportion to the significance of its ideas, was to lead to some of the banalities found in later Victorian narrative painting, and many Pre-Raphaelite works derived from literary themes betray an inability to distinguish between true poetic statement and illustration. One such casualty is Hunt's painting of *The Finding of the Saviour in the Temple* (Plate 11). Many characteristically Pre-Raphaelite features are present: the even, unshaded lighting, the tautness of contour, the high colour and the breathtaking accuracy of detail. Yet the obvious failure to communicate the metaphysical significance of the scene stems from the fact that not only does the painting attempt to illustrate, rather than evoke, but that, by

filling in every imaginable physical contour, it tries to furnish a comprehensible framework upon which the Victorian public (which had only the most skeletal of intellectual traditions behind it) could hang an aesthetic judgement.

Rossetti's *Ecce Ancilla Domini* (Plate 1) demonstrates, with much greater success, how symbols and details can be made to work towards a poetic statement. An almost blazing whiteness dominates the entire composition, but it is punctuated significantly by the emblematic colours of blue, red and gold, colours which, through their long association in the European traditions of religious painting, take on all the cognitive and affective weight of devotional art. The naturalistic screen behind the recoiling Virgin, painted in a dazzling Marian blue, thus suggests, but does not illustrate, the time-honoured associations of Virginity with motherhood, of joy with sorrow – associations which give this work its curious metaphysical timbre, even though its details are worked out in the spirit of nineteenth-century naturalism. This painting also exhibits certain traits found in several early Pre-Raphaelite canvases, particularly the use of a steeply rising perspective, which tilts the shallow depth of the room forward, so that it seems to spill out its contents before the viewer. It is a device that cancels the traditional aesthetic distance maintained between the painted surface and the spectator, pushing the image towards the viewer, so that its immediacy is abruptly brought home. One's nearness to such pictures, together with their strident colour and etched contours, contributes to the emotional engagement demanded by their authors, and if the method was unsubtle, it further indicates the degree of apathy which the Pre-Raphaelites felt they had to attack in their public. But the risk of alienation that they ran with such methods was not sufficiently calculated: the moral earnestness which typifies their original efforts, and which stamps them indelibly as mid-Victorian aestheticians, was to become, paradoxically, the progenitor of a detachment in art that has become one of the major critical and aesthetic principles of the twentieth century.

While Rossetti's success in *Ecce Ancilla Domini* can be seen in the formal patterns of his painting, it has ultimately to be explained in relation to his personality. Brought up in an intensely literary family, and steeped from earliest childhood in the works of Dante, of which his father was a scholar, he had developed a passionate imaginative identification with the medieval poet, in whose verse the sacramental view of life reaches its most complete expression, and where, in the words of Walter Pater, 'the spiritual attains the definite visibility of a crystal'. For Rossetti, therefore, the symbols and outward forms of the medieval world are nourished by a dramatic sense of their sacramentalism, which evaporates in the work of painters such as Arthur Hughes, whose treatment of medieval allegory is suggestive of a sweet nostalgia, rather than of an impassioned sense of its reality. For Rossetti, the sincerity of art had to be interpreted through the experience of life most genuine to him, which was not to be found, as it was for both Hunt and Millais, in the phenomenal world of everyday life, but rather in the imaginative life of literature and legend. The painting in which Rossetti achieves the most profound identity with Dante is *Beata Beatrix* (Plate 40), painted in 1863, the year after the death of his wife, Elizabeth Siddal. They had been introduced in 1850, and Rossetti's fundamentally Romantic soul responded to her as it did to the images of literature, which gave shape and outline to his fired, but molten, imagination. Elizabeth Siddal became Rossetti's Beatrice, the idealized love of Dante and the symbol of Theology in his work, who leads the medieval poet towards a vision of God in Paradise. In Rossetti's work, Elizabeth Siddal is subtly transmuted from the symbol of Theology to the symbol of Art, leading the painter towards a vision of a unified reality, where mortality and immortality, past and present, fact and symbol, are reconciled in the image of beauty. In *Beata Beatrix*, Rossetti comes closest to conveying the reality of the mystical, romantic world of the medieval poet, for the symbols in the painting are all as evocative of Dante's yearning for Beatrice as they are of Rossetti's mourning over his dead wife, of whom this painting is also a memorial portrait. The

sundial points to nine, the age of Beatrice's death, and also the hour at which Elizabeth Siddal was close to death. (She died soon after dining one evening with Rossetti and Swinburne and was found dead by her husband on his return home that same evening.) The scarlet dove carries a white poppy in its beak, a curious reversal of pictorial conventions, which reverberates with implications of the intermingling of sex and innocence, sickness (Lizzie Siddal died of an overdose of laudanum) and spiritual health. The figures of Love and Dante walk in the shaded groves behind Beatrice, who, in the moment of death, appears rapturous. The moment of ecstasy, in which the passions of the spirit are fused with the passions of the body is loaded with theological references to the Passion of Christ, in which death and resurrection, damnation and redemption, are merged into the single image of the crucifix. The passion of Beatrice, expressed by the cruciform composition, with the figures of Love and Dante on either side of her vertical figure, is also stated in the range of colour, limited almost exclusively to red and green. These colours face each other on the colour spectrum: but their opposition is complementary. They exist independently as opposite dimensions of the same entity, reflecting each other even in the physical absence of one or the other – as it is with the total fusion of reality, expressed sacramentally in the ritual of the Eucharist, profanely in the act of love, where the body becomes one with the spirit in its most intensely realized experience. Rossetti paints passionately here, affirming that, both as a testament to the memory of his wife and as a substantiation of the mysticism of the *Divine Comedy*, the spirit of art transcends mortality as the spirit of theology transcends the flesh.

The complexities of this work demand verbal explanation in a way that makes this sort of painting literary in all senses of the word, and its emotional urgency will carry only to those who develop an indulgent sympathy for such subjectivity. Others will see in it only a morbid and religiose fascination with death. These latter aspects were developed in the work of Rossetti's many admirers in the following decades, and not least by Rossetti himself, whose work becomes increasingly emotionally flaccid by the 1870s. In *The Blessed Damozel* (Plate 41), painted between 1871 and 1877, the deceased maiden looks languorously over the balcony of heaven towards her lover below. Paradise for her lies fully corporeal on the earth. Her listlessness conveys the bridled yearnings of physical love, but it is as if she were looking down from the raised end of a see-saw, her love-object weighted permanently to the ground. Melancholy and distance are suggested by the veiled and indistinct forms of the painting: the tighter, sharper surfaces of Rossetti's earlier works give way here to slow rhythms and arabesques, as if the taut control of sentiment has gone slack. As he painted on into the 1880s, creating on canvas the lush and brooding women with whom, for many, the image of Pre-Raphaelite womanhood has become permanently associated, Rossetti betrayed the emotional control of his earlier intensity, and best describes this later self-indulgence in his own words: 'Look in my face, my name is Might-have-been; I am also called No-more, Too-late, Farewell.' (*A Superscription*, 1870.)

In the 1850s, however, Rossetti had made a unique contribution to nineteenth-century art with a series of lapidary watercolours on themes from Arthurian legend. In *Sir Galahad at the Ruined Chapel* (Plate 38) opaque watercolour is used with all the density and lambency of medieval stained glass or *cloisonné* enamels to describe the emblazoned and heraldic world of Arthurian romance. The vividness of colour and the small format emphasize the physicality of the scene by bringing it closer to the viewer. Yet the fact that this is about the knights and spiritual quests of medieval legend acts as a foil to the sensuality, and reminds one of the abyss that separated romance from reality in the nineteenth-century world. Rossetti's consciousness of these irreconcilable opposites, his appreciation of the mentality that could conceive of the ideal woman as both a Virgin and a Mother, enables him to penetrate imaginatively into the courtly and chivalric world of medieval romance, and to convey it with an enlivened sense of its reality.

The difference in temperament between Rossetti, Hunt and Millais could hardly have been more marked, and it is one explanation for the wide divergence of style associated with Pre-Raphaelitism. Millais, from the outset, had a natural facility denied to both Hunt and Rossetti. In *Lorenzo and Isabella* (Plate 4), the first painting he exhibited as a Pre-Raphaelite, he shows an easy command of their tenets, in the modelling of flat surfaces, the hardness of outline and the evenness of illumination. The very awkwardness of the picture – from the gaucheness of the falcon perched symbolically beside the belligerent brother, and the liquid-eyed dog held in the lap of a caressing Isabella, to the confused perspectives of the table and the supposedly projecting balcony on the right – stimulates, rather than confuses, the sense of wilful, if tense, control behind the image. But this control and surface hardness was basically inimical to Millais's nature, which was less imaginatively charged than that of Rossetti, less morally fervid than that of Hunt. The progress of Millais's art is a gradual relaxation of his Pre-Raphaelite stringency towards the docility of his later and immensely popular pictures such as *Bubbles* (Pears Foundation) and *Sweetest Eyes* (Edinburgh, National Gallery of Scotland). But during the early 1850s, while still working within the framework of the Brotherhood, he painted such lyrical pictures as *The Return of the Dove to the Ark* (Plate 12) and *Autumn Leaves* (Plate 15). The special poignancy of this last work goes beyond the elegiac use of colour and the wistful nostalgia of the theme, for it is one of the last canvases in which Millais put his facility to positive rather than negative effect. Though there is a tendency to sentimentalize here, it is submerged and held firm beneath the subtleties of colour. The season of incipient decay, for the young girls on the heath as for their Pre-Raphaelite painter, blows its chill air in, but it is as yet warned off by the smouldering warmth from the bonfire and the glowing tones of the leaves.

Holman Hunt remained faithful to the narrowest interpretation of the rules of 'truth to nature' throughout his career. His particular method of painting landscape, as if every stalk and reed were flooded with a concentrated beam from an arc-light, was taken up by many exponents of the movement, such as John Brett, William Dyce and William Davis. Where Hunt had pioneered, however, and Ford Madox Brown too, as illustrated in his luminous landscape of *Walton-on-the-Naze* (Plate 27), was in the reflective rather than simply local use of colour, the revolutionary impact of which was fully implemented by the Impressionists working in France a decade later. Sadly, the admirers of Hunt did not develop the possibilities of this innovation, and though their works are based on the scientific recording of natural data, they also illustrate the fallacy of believing that the total extent of reality can be revealed in fact, and in fact only. One might argue that Davis, and possibly Brett too, confused science with scientism, material with materialism. Science was certainly one of the moulds in which the old body of religious values was being recast in the nineteenth century. The almost religious faith in science, which, it was believed, could provide an exact knowledge of reality itself, and which was being applied methodologically to all branches of human experience, had its champion in John Stuart Mill, whose arguments are as far removed from those of Carlyle as is Davis's *At Hale, Lancashire* (Plate 24) from Rossetti's *Beata Beatrix*. The bridge by which the Pre-Raphaelites tried to span the gap, at least until the early 1860s, was built of a common ground of moral and social responsibility towards the different realities affecting them.

A contemporary critic of the movement commented perceptively about Rossetti's work that 'he runs the risk of missing men's response, not to the beauties of his style, but to the images of his thought.' The difficulties that the first exponents of Pre-Raphaelitism had found in maintaining a meaningful aesthetic tension between the integrity of detail and the imaginative unity of genuine human experience are diffused by the generation of painters working from the 1860s into the 1880s, who admired and emulated the style of the first generation of Pre-Raphaelites, but who brought to it a detachment from the sphere of moral aesthetics that distinguishes their work from that of their predecessors.

Among the many artists who appropriated 'the beauties' of Rossetti's style are those who knew him personally and worked closely with him: Burne-Jones, William Morris and Frederick Sandys. Although the subjectivity of their work as a whole has frequently been regarded as so much escapism and romantic reverie, many individual canvases bear closer attention for the parallels they draw with late nineteenth-century enquiries into psychology and the workings of the mind. Such an analogy will doubtless seem gratuitous when one first looks at Burne-Jones's *Phyllis and Demophoön* (Plate 47), which, technically, restores the academic tradition of classical beauty to the pantheon of respectability. This classical myth, however, takes on a strange and distorted dimension, its static atmosphere and its attenuated figures giving it the unsubstantial reality of a dream landscape. Similar adaptations of classical myths were being developed concurrently in Germany by Arnold Böcklin, Max Klinger and Franz von Stuck, and in France by Gustave Moreau and Puvis de Chavannes – an indication of a pan-European concern with the expression of complex states of consciousness in intelligible plastic form. By this date, scientific analysis was probing the area of the mind, but this new area of reality had not yet yielded a communicable system of symbols by which it could be read and understood. In its own way, *Phyllis and Demophoön* adopts time-honoured classical symbols to communicate the existence of another reality, dim and primordial, and beneath the surface of conscious life, but existing none the less parallel to the tangible world of Gladstone, Disraeli, and the colonial Empire. The problem facing the artist involved in the exploration of the purely inner world of consciousness was that his pictorial metaphors would become increasingly subjective and unintelligible to the public, so that they would eventually exist only in the realm of fantasy. Much of Burne-Jones's work suffers badly from this, and regrettably, his fantasies do not have the distinction of being particularly interesting.

When one looks at Sandys's *Morgan-le-Fay* (Plate 45) it becomes evident that the appropriation of the superficial aspects of Rossetti's style – the semi-erotic ecstasy of expression, the necromancy of the theme – misses entirely Rossetti's 'images of thought'. Rossetti's fascination with objects of a curious design was such that he used them as props in his work to guide the progress of the drama. In Sandys's work, though the brazen ornaments and inlaid cabinets are painted with a skill that undoubtedly exceeded Rossetti's slim technical talent, the curios have no vitality. They accumulate on the canvas without purpose; in their lifelessness they embody the principle upon which bric-à-brac is distinguished from a genuine antique, a principle that may also serve usefully to distinguish Sandys's work from that of Rossetti.

While Burne-Jones was influenced by Rossetti in the early years of his career as a painter, he soon developed a personal style in which formal elements came to constitute the essential point of his work. This was a radical departure from earlier Pre-Raphaelite practice, which had tended to emphasize thematically, rather than formally, the ideas put forward in its canvases. One feels, given the acceptance of formalist aesthetics in the twentieth century, that Burne-Jones's work ought to be more generally successful than it is. That it was influential in energizing the currents of Art Nouveau is undeniable, but Art Nouveau finds its true level in the applied arts, rather than in painting, and this gives us a clue to where Burne-Jones's weakness lies. In *The Arming of Perseus* (Plate 46), for example, the jagged linearism, striking though it is, is impressive before it is meaningful, aesthetically exciting before it is emotionally genuine, a question, in the phrase of Oscar Wilde, of 'manners before morals'. One is reminded also of Wilde's words in the preface to *The Picture of Dorian Gray*, which, although they refer specifically to books, can be applied equally well to works of art in general: 'There is no such thing as a moral or an immoral book. Books are well written or badly written. That is all.' These words epitomize the spirit of the decadent nineties, and sum up the attitude behind the beautiful, decorative and morally pointless works of J. M. Strudwick and Evelyn de Morgan (Plates 42 and 43). It is a far cry from the committed works of the original Pre-Raphaelites.

The tendency in these later paintings to cultivate a consciously artistic pose and hence, inevitably, an artificial one, was to lead to the debasement of the principles upon which the Pre-Raphaelite Brotherhood had been established and by which its adherents had sought to come to grips with the essentials of human existence, with history and the unseen. The movement had originally formed part of that deepening of seriousness which had also shown itself in the evangelism of Cardinal Newman and the Utopian Socialism of William Morris; but the seeds of divorce between moral and aesthetic harmony had been sown from its inception, and eventually produced such curious late blooms as John Byam Shaw's *The Boer War* (Plate 48). The nostalgia of this work with its inbred languor, its preciously painted surface, and its remoteness from the grisly realities of war, provides a fitting comment on the exhausted ideals of the founding members of the movement, and with the lines by Christina Rossetti which accompany it, serves as an elegy for an ageing cause:

> Last summer green things were greener
> Brambles fewer, the blue sky bluer.

Shaw's painting looks back almost fifty years to the first Pre-Raphaelite exercises of Millais and Holman Hunt, and records the impasse which Pre-Raphaelite painting had reached by the turn of the century. But the ideas which the movement had propagated about design, craftsmanship and the relation of art to society were taking root solidly in the Arts and Crafts Movement by this date, and were encouraging the production of artifacts expressive of a fresh contact with technical realities, and which were to take Pre-Raphaelitism into the twentieth century with renewed vigour.

List of Plates

1. DANTE GABRIEL ROSSETTI (1828–82): *Ecce Ancilla Domini* (also known as *The Annunciation*). 1849–50. Canvas, 72·4 × 41·9 cm. London, Tate Gallery.

2. DANTE GABRIEL ROSETTI (1828–82): *The Girlhood of Mary Virgin*. 1849–9. Canvas, 83·2 × 65·4 cm. London, Tate Gallery.

3. WILLIAM HOLMAN HUNT (1827–1910): *Claudio and Isabella*. 1850. Panel, 77·5 × 45·7 cm. London, Tate Gallery.

4. JOHN EVERETT MILLAIS (1829–96): *Lorenzo and Isabella*. 1849. Canvas, 99·1 × 142·9 cm. Liverpool, Walker Art Gallery.

5. JOHN EVERETT MILLAIS (1829–96): *Christ in the House of his Parents* (also known as *The Carpenter's Shop*). 1849–50. Canvas, 86 4 × 139·7 cm. London, Tate Gallery.

6. JAMES COLLINSON (1825–81): *The Renunciation of Queen Elizabeth of Hungary* (detail). About 1848–50. Canvas, 120·3 × 181·6 cm. Johannesburg Art Gallery.

7. CHARLES ALLSTON COLLINS (1828–73): *Berengaria Recognizing the Girdle of Richard I Offered for Sale in Rome* (also known as *The Pedlar*). 1850. Canvas, 101·2 × 106·7 cm. Manchester City Art Gallery.

8. CHARLES ALLSTON COLLINS (1828–73): *Convent Thoughts*. 1850–1. Canvas, 84 × 59 cm. Oxford, Ashmolean Museum.

9. JOHN EVERETT MILLAIS (1829–96): *Mariana*. 1851. Panel, 59·7 × 49·5 cm. Collection of Lord Sherfield.

10. WILLIAM HOLMAN HUNT (1827–1910): *Valentine Rescuing Sylvia from Proteus*. 1851. Canvas, 98·4 × 133·4 cm. Birmingham City Museums and Art Gallery.

11. WILLIAM HOLMAN HUNT (1827–1910): *The Finding of the Saviour in the Temple*. 1854–60. Canvas, 85·7 × 141 cm. Birmingham City Museums and Art Gallery.

12. JOHN EVERETT MILLAIS (1829–96): *The Return of the Dove to the Ark*. 1851. Canvas, 88 × 55 cm. Oxford, Ashmolean Museum.

13. WILLIAM HOLMAN HUNT (1827–1910): *The Festival of St Swithin* (also known as *The Dovecot*). 1866–75. Canvas, 73 × 91 cm. Oxford, Ashmolean Museum.

14. JOHN EVERETT MILLAIS (1829–96): *The Blind Girl*. 1856. Canvas, 82·6 × 61·6 cm. Birmingham City Museums and Art Gallery.

15. JOHN EVERETT MILLAIS (1829–96): *Autumn Leaves*. 1856. Canvas, 104·1 × 74 cm. Manchester City Art Gallery.

16. FREDERICK GEORGE STEPHENS (1828–1907): *Mother and Child*. About 1854–5. Canvas, 47 × 64·1 cm. London, Tate Gallery.

17. FORD MADOX BROWN (1821–93): *Pretty Baa-Lambs*. 1851–9. Canvas, 59·7 × 74·9 cm. Birmingham City Museums and Art Gallery.

18. FORD MADOX BROWN (1821–93): '*Take Your Son, Sir!*' 1857. Unfinished. Canvas, 69·9 × 38·1 cm. London, Tate Gallery.

19. FORD MADOX BROWN (1821–93): *The Last of England*. 1855. Oval. Panel, 82·6 × 74·9 cm. Birmingham City Museums and Art Gallery.

20. FORD MADOX BROWN (1821–93): *Work*. 1852–65. Canvas, 137·2 × 197·5 cm. Manchester City Art Gallery.

21. JOHN BRETT (1830–1902): *The Stonebreaker*. 1857–8. Canvas, 49·5 × 67·3 cm. Liverpool, Walker Art Gallery.

22. WILLIAM BELL SCOTT (1811–90): *Iron and Coal* (detail). About 1855–60. Canvas, 188 × 188 cm. Wallington, Morpeth, The National Trust (Trevelyan Collection).

23. HENRY WALLIS (1830–1916): *The Stonebreaker*. 1857. Panel, 65·4 × 78·7 cm. Birmingham City Museums and Art Gallery.

24. WILLIAM DAVIS (1812–73): *At Hale, Lancashire*. About 1860. Board, 31·8 × 48·9 cm. Liverpool, Walker Art Gallery.

25. WILLIAM HOLMAN HUNT (1827–1910): *Our English Coasts* (also known as *Strayed Sheep*). 1852. Canvas, 43·2 × 58·4 cm. London, Tate Gallery.

26. FORD MADOX BROWN (1821–93): *An English Autumn Afternoon*. 1852–4. Oval. Canvas, 69·9 × 134·6 cm. Birmingham City Museums and Art Gallery.

27. FORD MADOX BROWN (1821–93): *Walton-on-the-Naze*. 1859–60. Canvas, 31·8 × 41·9 cm. Birmingham City Museums and Art Gallery.

28. WILLIAM DYCE (1806–64): *Pegwell Bay, a Recollection of October 5th, 1858*. 1859–60. Canvas, 63·5 × 88·9 cm. London, Tate Gallery.

29. WILLIAM DYCE (1806–64): *George Herbert at Bemerton*. First exhibited 1861. Canvas, 86·4 × 111·8 cm. City of London, Guildhall Art Gallery.

30. JOHN BRETT (1830–1902): *February in the Isle of Wight*. 1866. Watercolour and bodycolour on paper, 40 × 35·2 cm. Birmingham City Museums and Art Gallery.

31. JOHN WILLIAM INCHBOLD (1830–88): *In Early Spring*. About 1870. Canvas, 50·8 × 34·9 cm. Oxford, Ashmolean Museum.

32. JOHN EVERETT MILLAIS (1829–96): *John Ruskin*. 1854. Canvas, 78·7 × 67·9 cm. Private Collection.

33. WILLIAM BELL SCOTT (1811–90): *Algernon Charles Swinburne*. 1860. Canvas, 46·4 × 31·8 cm. Oxford, Balliol College.

34. ARTHUR HUGHES (1830–1915): *Ophelia*. 1852. Canvas, 68·6 × 123·8 cm. Manchester City Art Gallery.

35. JOHN EVERETT MILLAIS (1829–96): *Ophelia*. 1851–2. Canvas, 76·2 × 111·8 cm. London, Tate Gallery.

36. ARTHUR HUGHES (1830–1915): *The Long Engagement*. 1859. Canvas, 105·4 × 52·1 cm. Birmingham City Museums and Art Gallery.

37. WILLIAM MORRIS (1834–96): *Queen Guenevere*. 1858. Canvas, 71·8 × 50·2 cm. London, Tate Gallery.

38. DANTE GABRIEL ROSSETTI (1828–82): *Sir Galahad at the Ruined Chapel*. 1859. Watercolour on paper, 29·2 × 34·3 cm. Birmingham City Museums and Art Gallery.

39. ARTHUR HUGHES (1830–1915): *The Knight of the Sun*. 1860. Canvas, 101·6 × 132·5 cm. Private Collection.

40. DANTE GABRIEL ROSSETTI (1828–82): *Beata Beatrix*. About 1863. Canvas, 86·4 × 66 cm. London, Tate Gallery.

41. DANTE GABRIEL ROSSETTI (1828–82): *The Blessed Damozel*. 1871–7. Canvas, 174 × 94 cm. Cambridge, Massachusetts, Fogg Art Museum.

42. JOHN MELLHUISH STRUDWICK (1849–1935): *The Gentle Music of a Bygone Day*. 1890. Canvas, 79·1 × 61·3 cm. Private Collection.

43. EVELYN DE MORGAN (1855–1919): *Flora*. Canvas, 198 × 88·3 cm. By Courtesy of the Trustees of the De Morgan Foundation.

44. WILLIAM LINDSAY WINDUS (1823–1907): *The Outlaw*. 1861. Canvas, 35·6 × 34·3 cm. Manchester City Art Gallery.

45. FREDERICK SANDYS (1832–1904): *Morgan-le-Fay*. 1864. Panel, 62·9 × 44·5 cm. Birmingham City Museums and Art Gallery.

46. EDWARD COLEY BURNE-JONES (1833–98): *The Arming of Perseus*. 1877. Tempera on canvas, 152·4 × 127 cm. Southampton Art Gallery.

47. EDWARD COLEY BURNE-JONES (1833–98): *Phyllis and Demophoön*. 1870. Gouache on paper, 91·5 × 45·8 cm. Birmingham City Museums and Art Gallery.

48. JOHN BYAM SHAW (1872–1919): *The Boer War*. 1901. Canvas, 100 × 74·9 cm. Birmingham City Museums and Art Gallery.

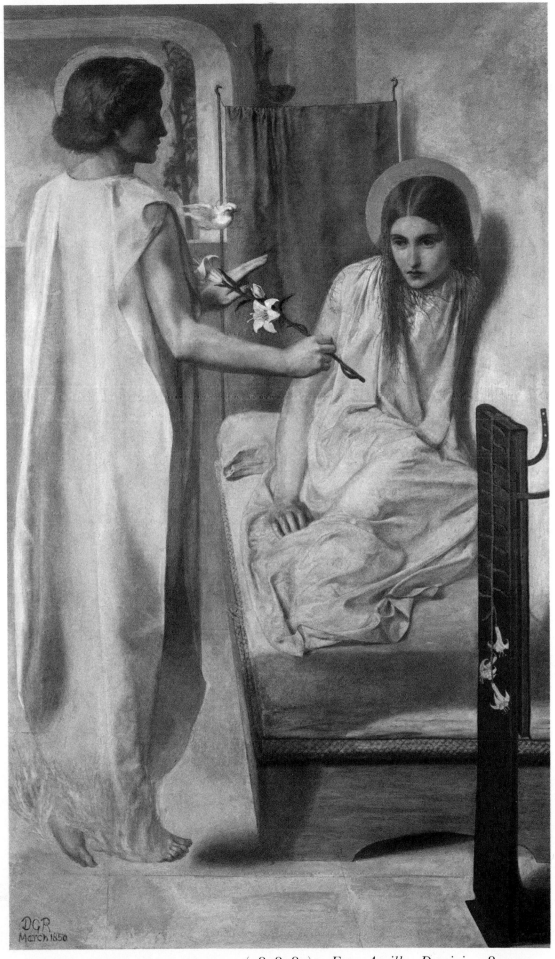

1. DANTE GABRIEL ROSSETTI (1828–82): *Ecce Ancilla Domini*. 1849-50.
London, Tate Gallery

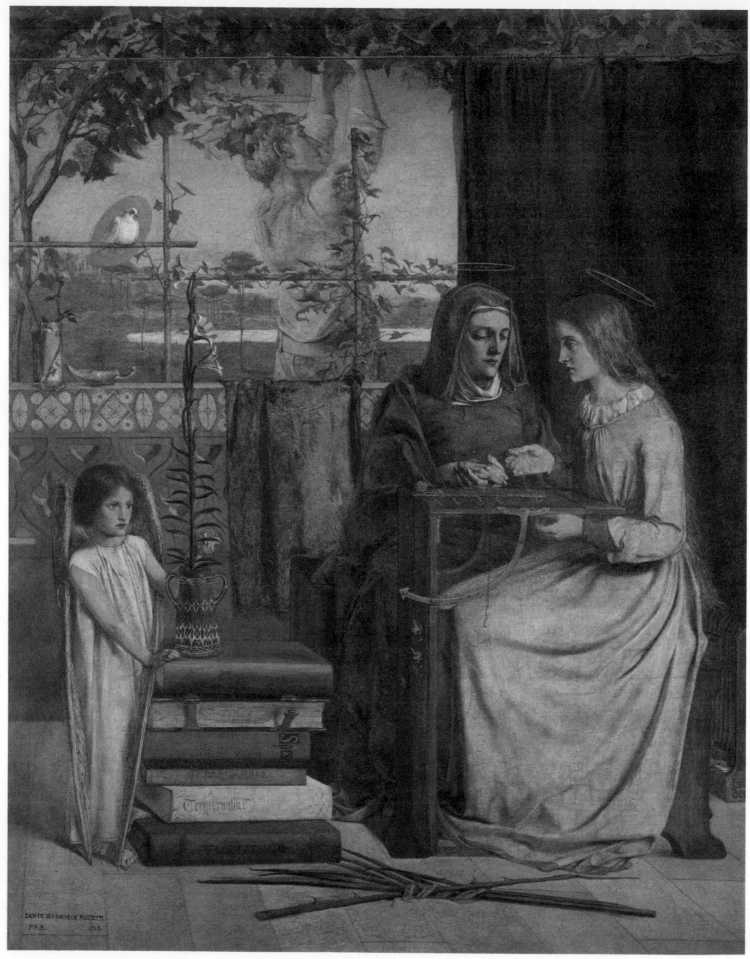

2. DANTE GABRIEL ROSSETTI (1828–82): *The Girlhood of Mary Virgin*. 1848–9. London, Tate Gallery

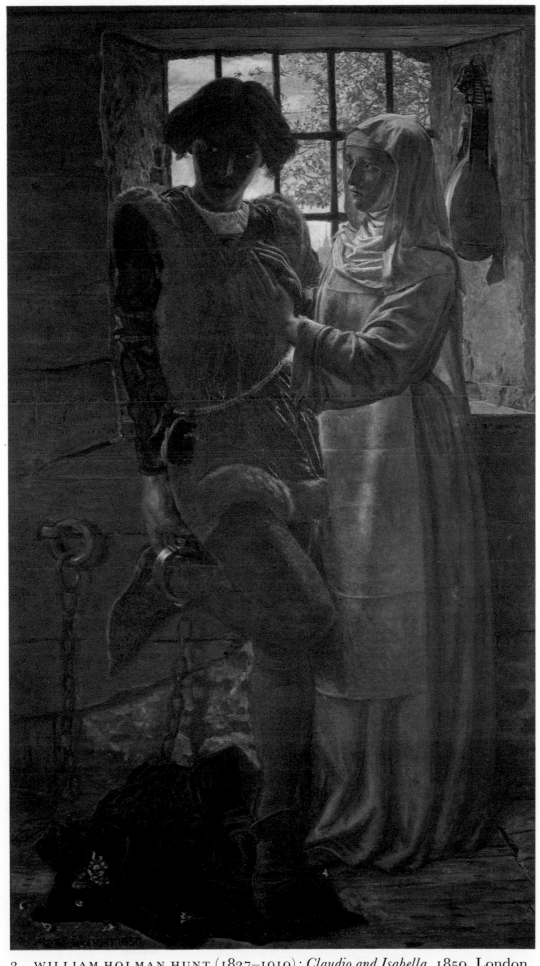

3. WILLIAM HOLMAN HUNT (1827–1910): *Claudio and Isabella*. 1850. London, Tate Gallery

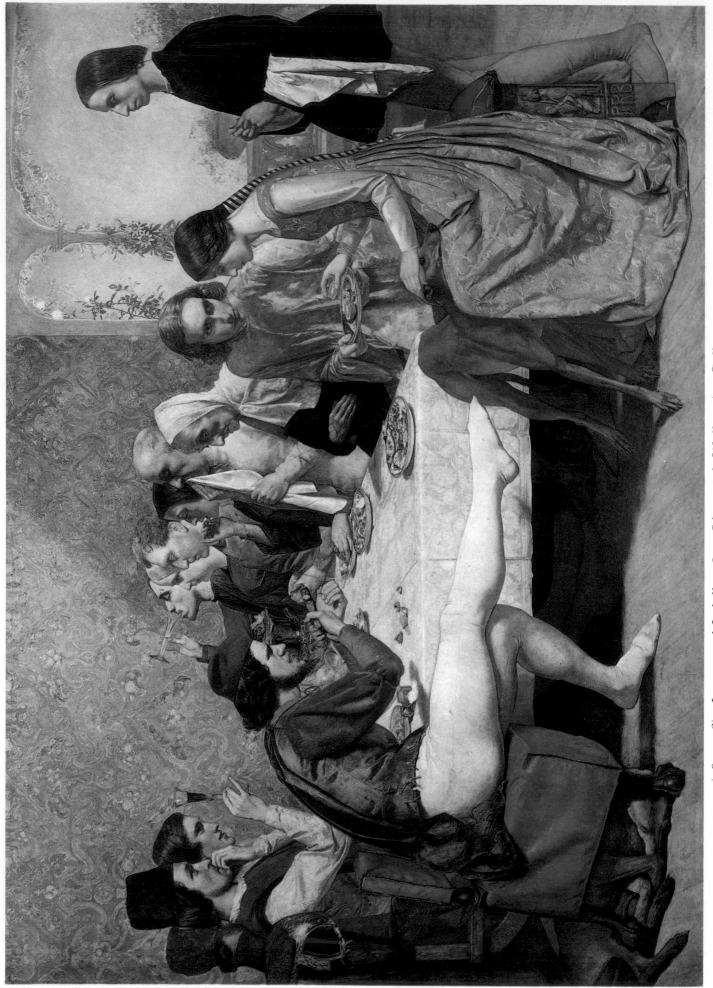

4. JOHN EVERETT MILLAIS (1829–96): *Lorenzo and Isabella.* 1849. Liverpool, Walker Art Gallery

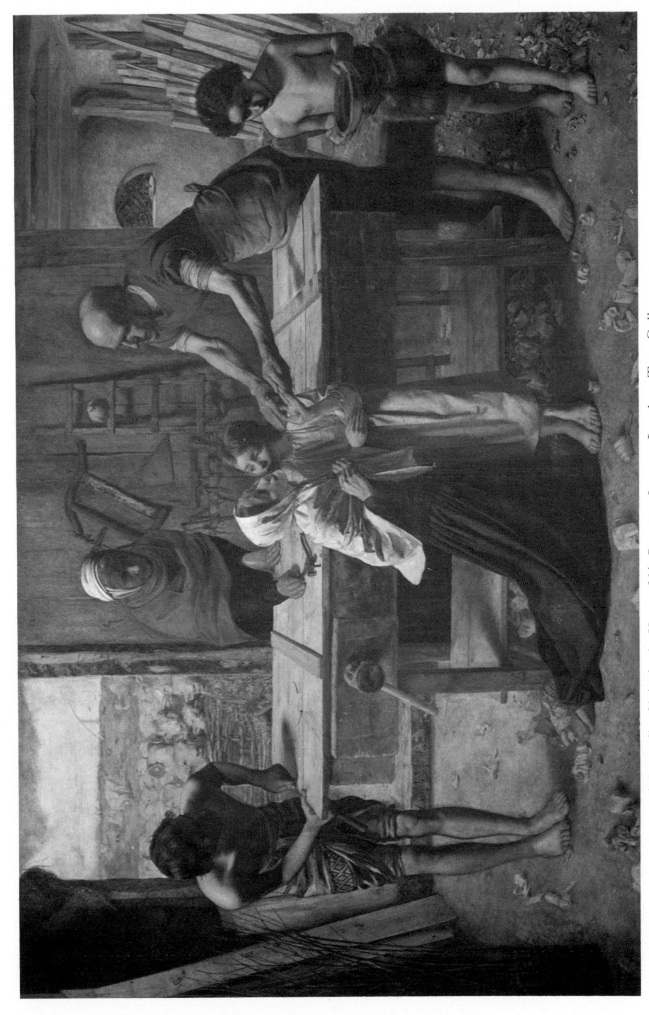

5. JOHN EVERETT MILLAIS (1829–96) : *Christ in the House of his Parents*. 1849–50. London, Tate Gallery

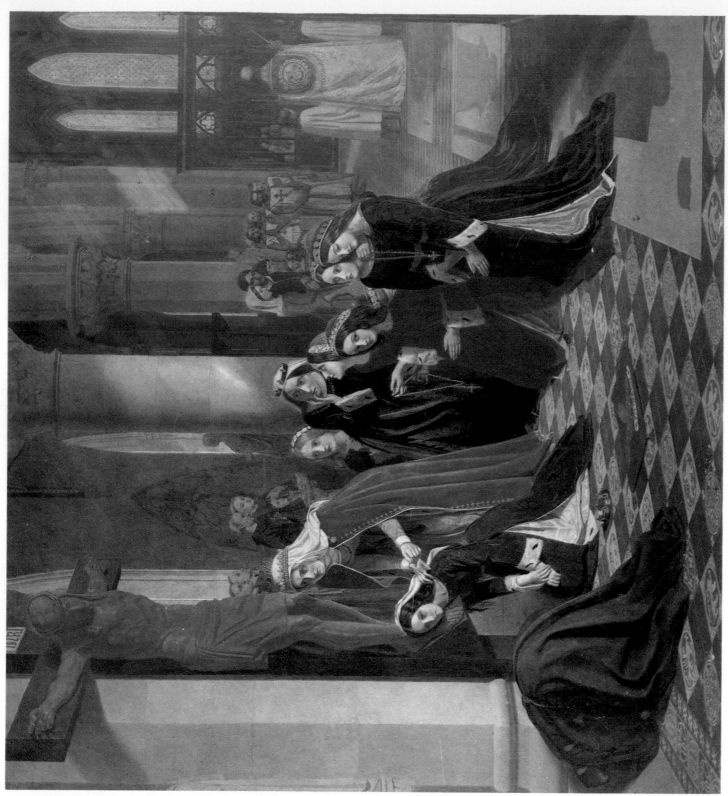

6. JAMES COLLINSON (1825–81): *The Renunciation of Queen Elizabeth of Hungary* (detail). About 1848–50. Johannesburg Art Gallery

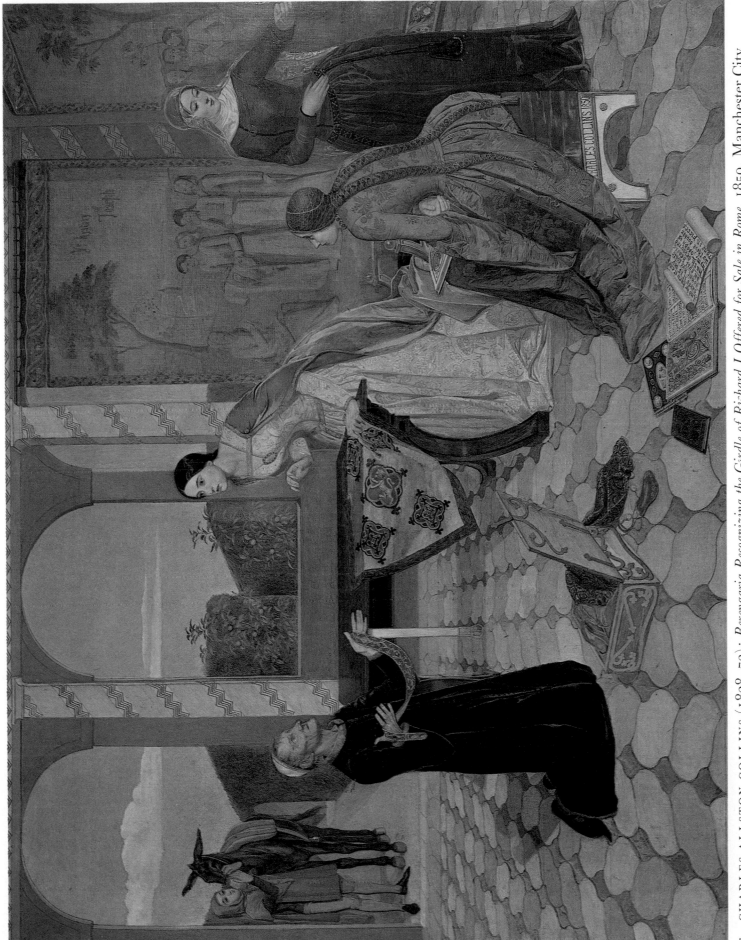

7. CHARLES ALLSTON COLLINS (1828–73) : *Berengaria Recognizing the Girdle of Richard I Offered for Sale in Rome.* 1850. Manchester City
Art Gallery

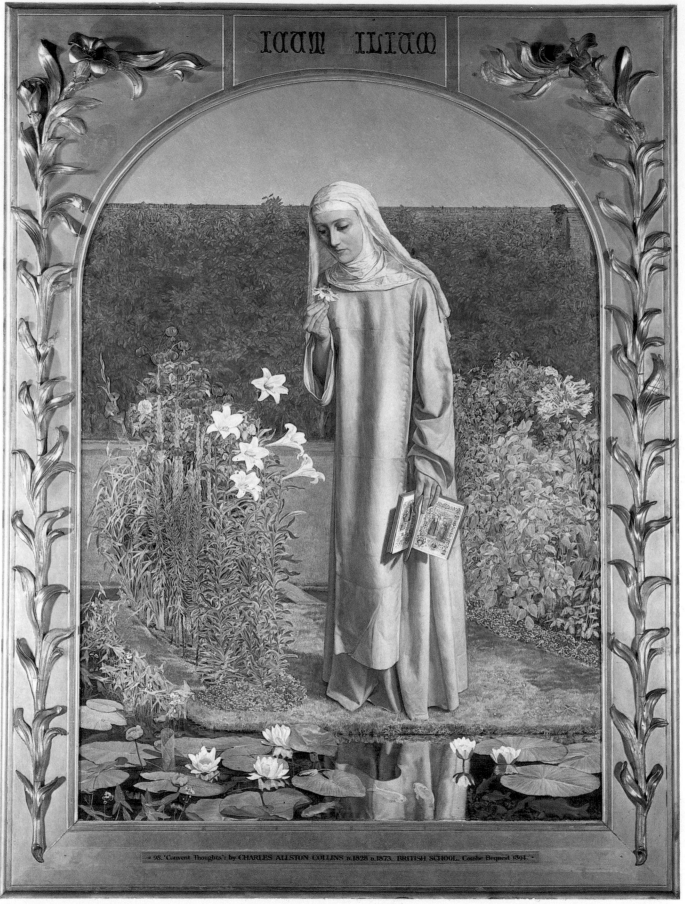

8. CHARLES ALLSTON COLLINS (1828–73): *Convent Thoughts*. 1850–1. Oxford, Ashmolean Museum

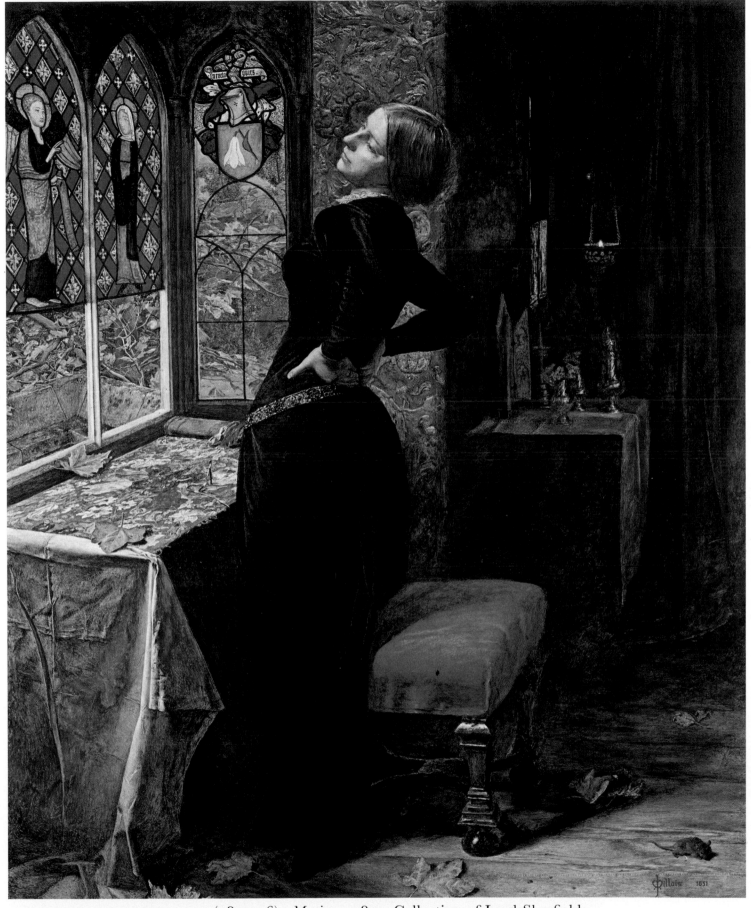

9. JOHN EVERETT MILLAIS (1829–96): *Mariana*. 1851. Collection of Lord Sherfield

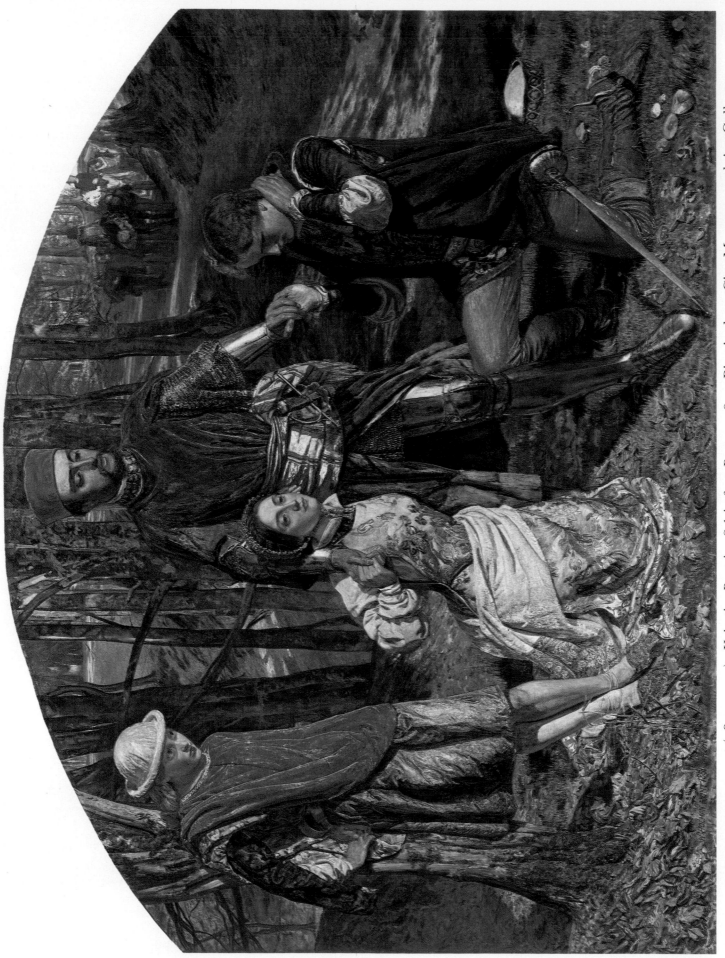

10. WILLIAM HOLMAN HUNT (1827–1910): *Valentine Rescuing Sylvia from Proteus*. 1851. Birmingham City Museums and Art Gallery

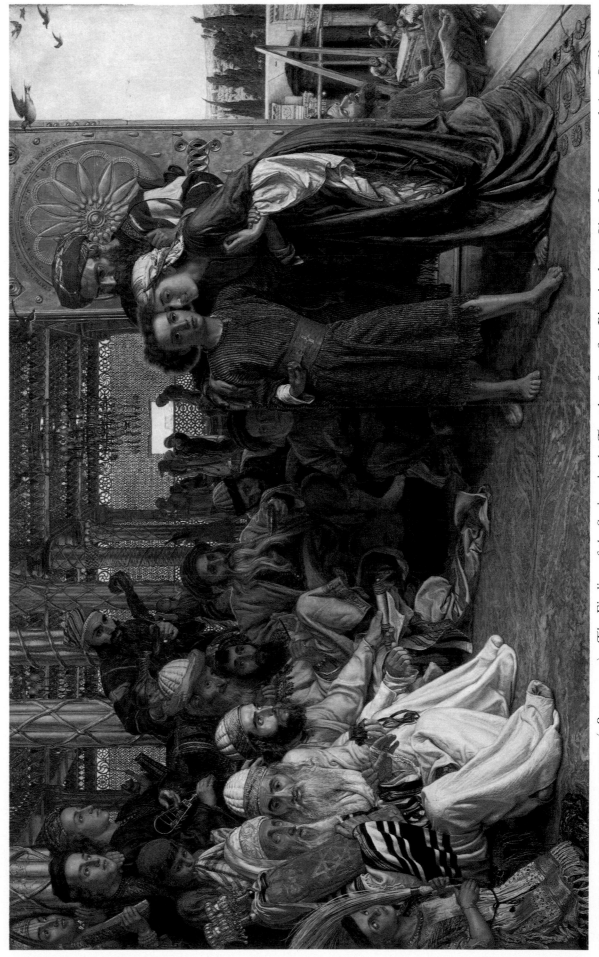

11. WILLIAM HOLMAN HUNT (1827–1910): *The Finding of the Saviour in the Temple*. 1854–60. Birmingham City Museums and Art Gallery

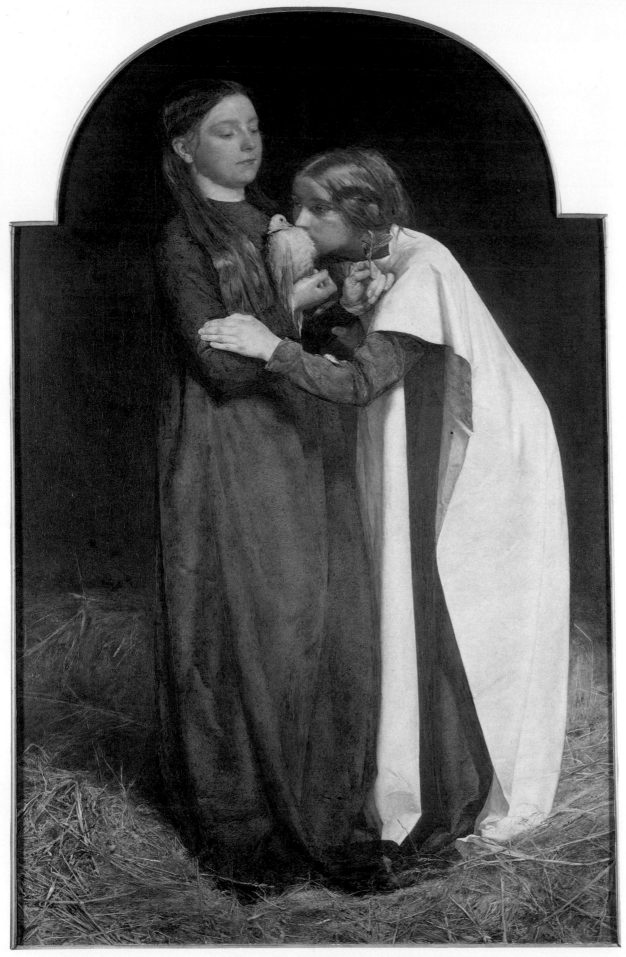

12. JOHN EVERETT MILLAIS (1829–96): *The Return of the Dove to the Ark*. 1851. Oxford, Ashmolean Museum

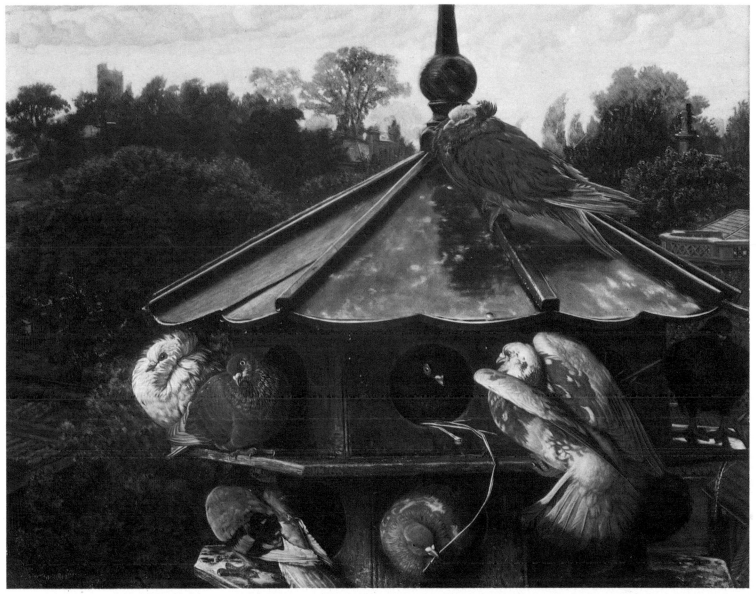

13. WILLIAM HOLMAN HUNT (1827–1910): *The Festival of St Swithin*. 1866–75. Oxford, Ashmolean Museum

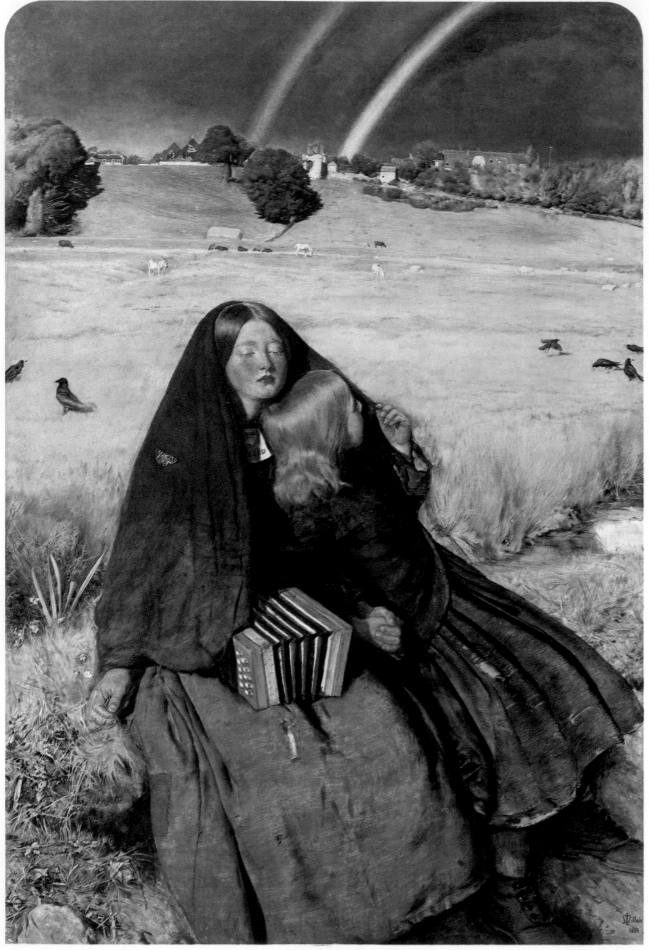

14. JOHN EVERETT MILLAIS (1829–96): *The Blind Girl*. 1856. Birmingham City Museums and
Art Gallery

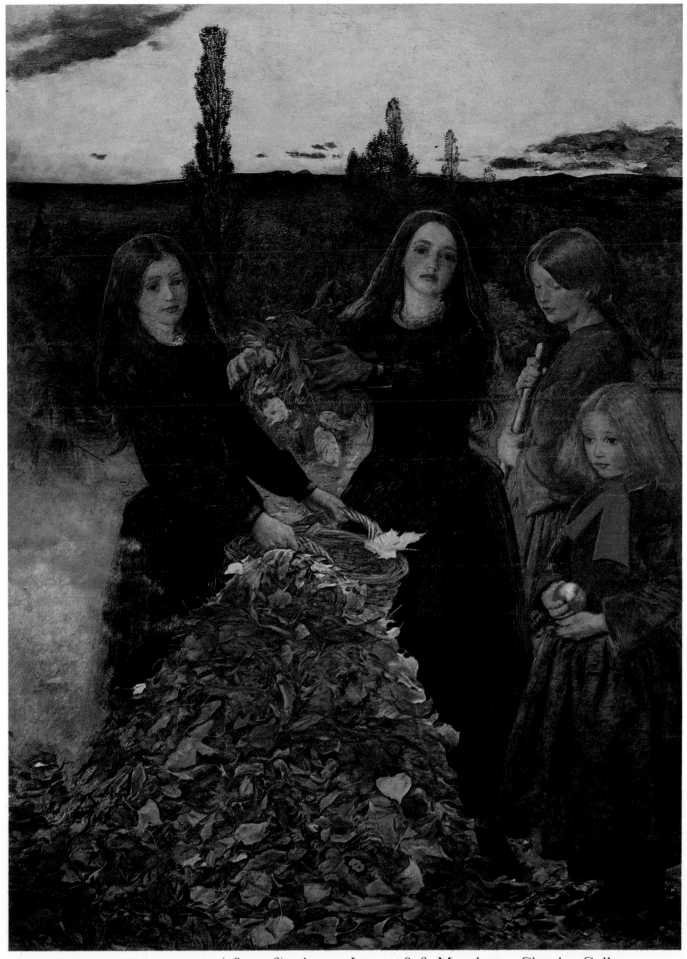

15. JOHN EVERETT MILLAIS (1829–96): *Autumn Leaves*. 1856. Manchester City Art Gallery

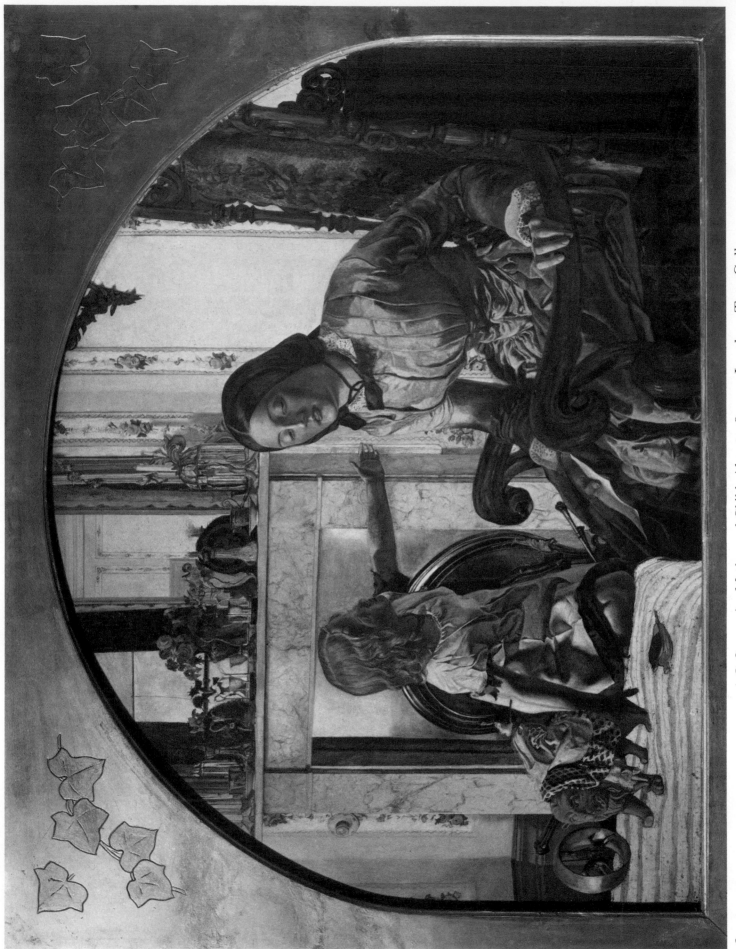

16. FREDERICK GEORGE STEPHENS (1828–1907): *Mother and Child. About* 1854–5. London, Tate Gallery

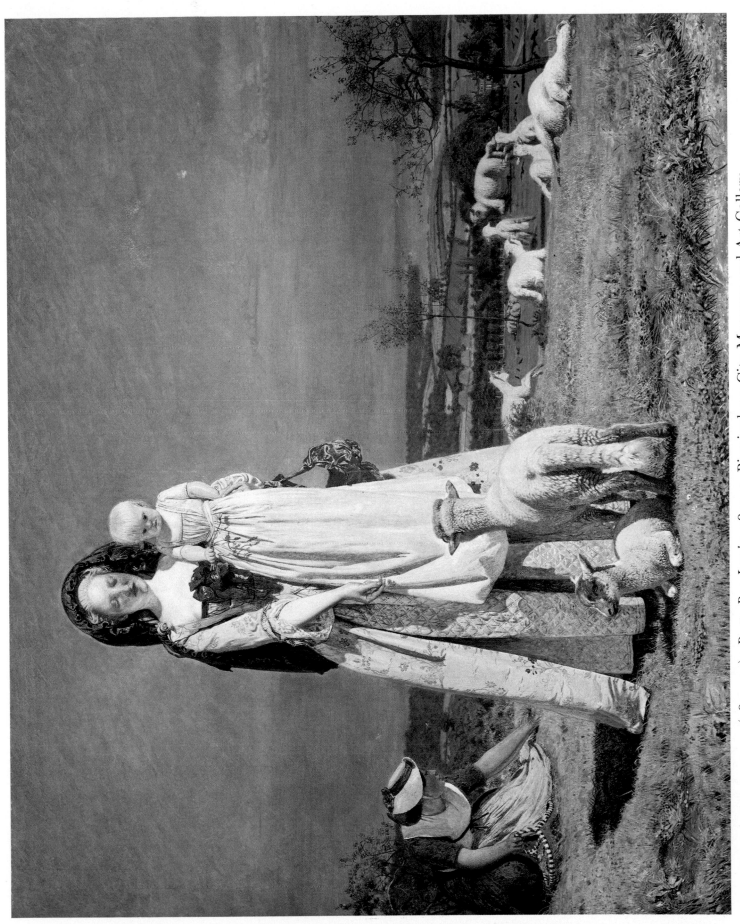

17. FORD MADOX BROWN (1821–93): *Pretty Baa-Lambs.* 1851–9. Birmingham City Museums and Art Gallery

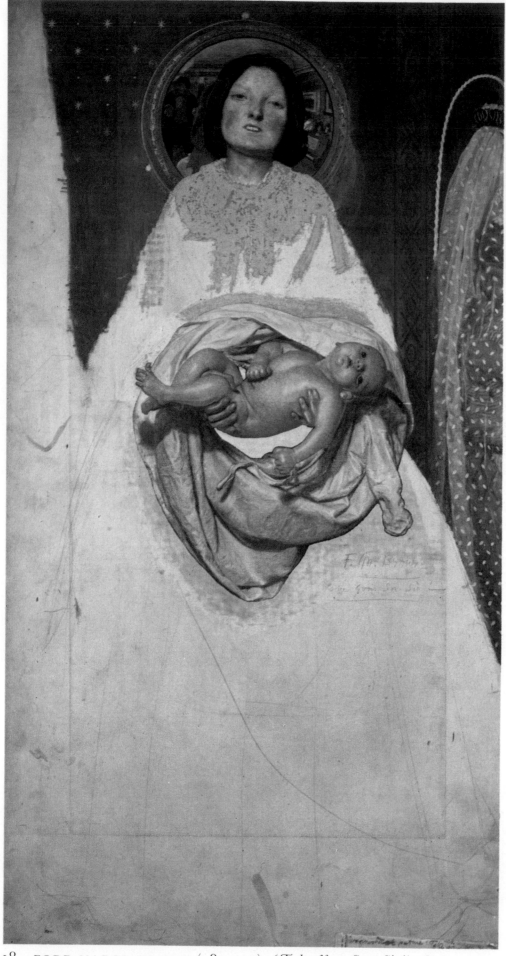

18. FORD MADOX BROWN (1821–93): *'Take Your Son, Sir!'* 1857.
London, Tate Gallery

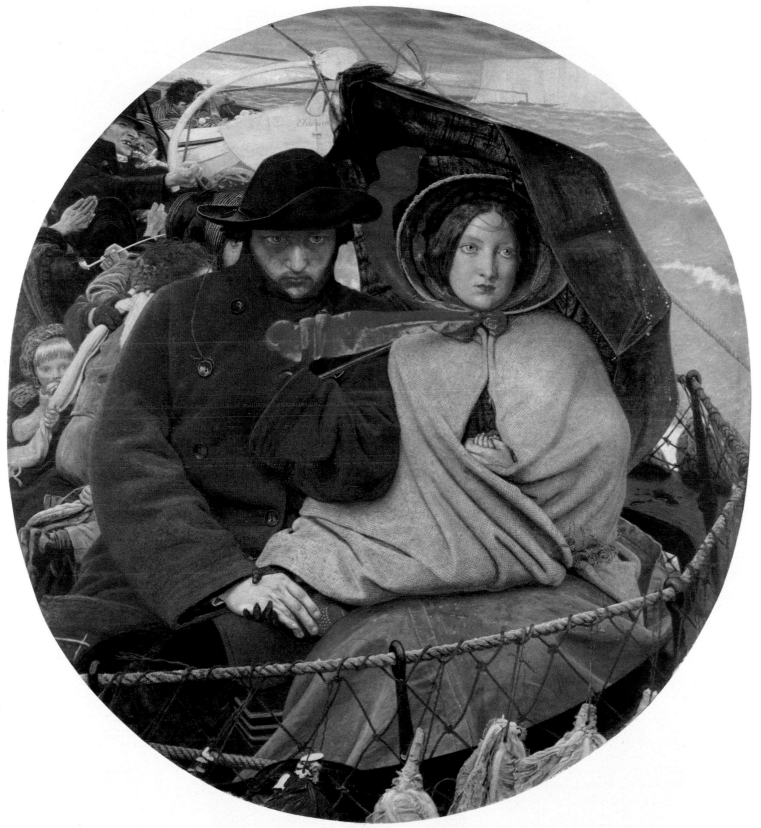

19. FORD MADOX BROWN (1821–93): *The Last of England*. 1855. Birmingham City Museums and Art Gallery

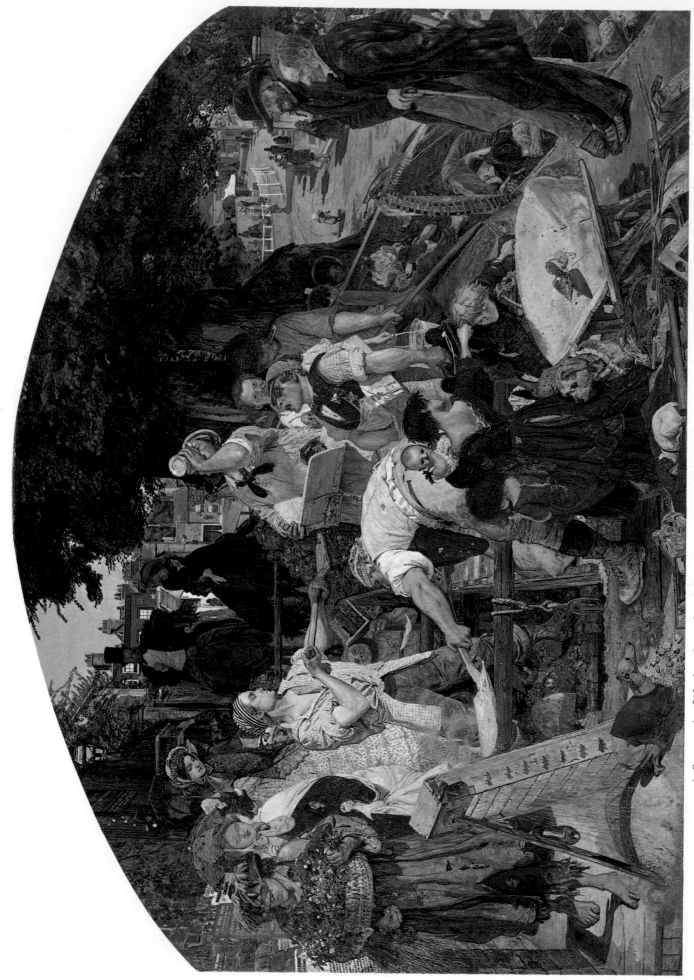

20. FORD MADOX BROWN (1821–93) : *Work.* 1852–65. Manchester City Art Gallery

21. JOHN BRETT (1830–1902): *The Stonebreaker*. 1857–8. Liverpool, Walker Art Gallery

22. WILLIAM BELL SCOTT (1811–90): *Iron and Coal* (detail). About 1855–60. Wallington, Morpeth, The National Trust (Trevelyan Collection)

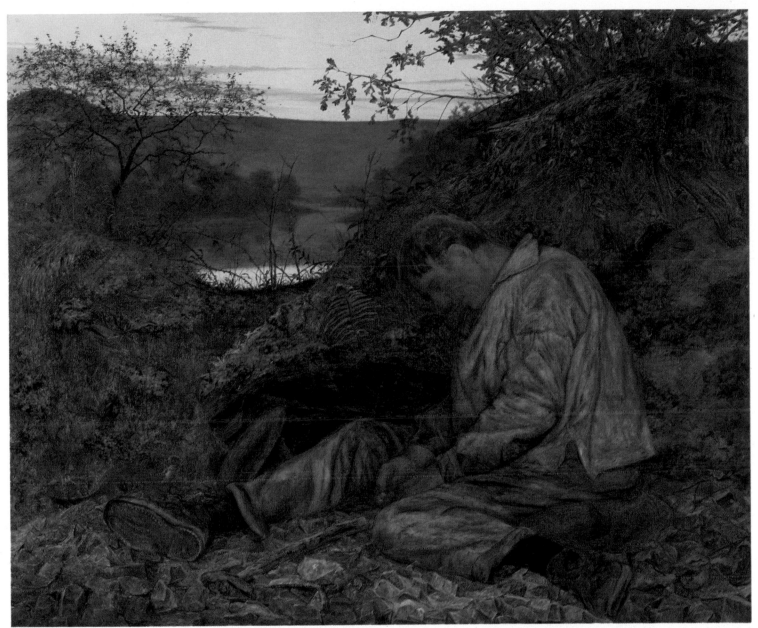

23. HENRY WALLIS (1830–1916): *The Stonebreaker*. 1857. Birmingham City Museums and Art Gallery

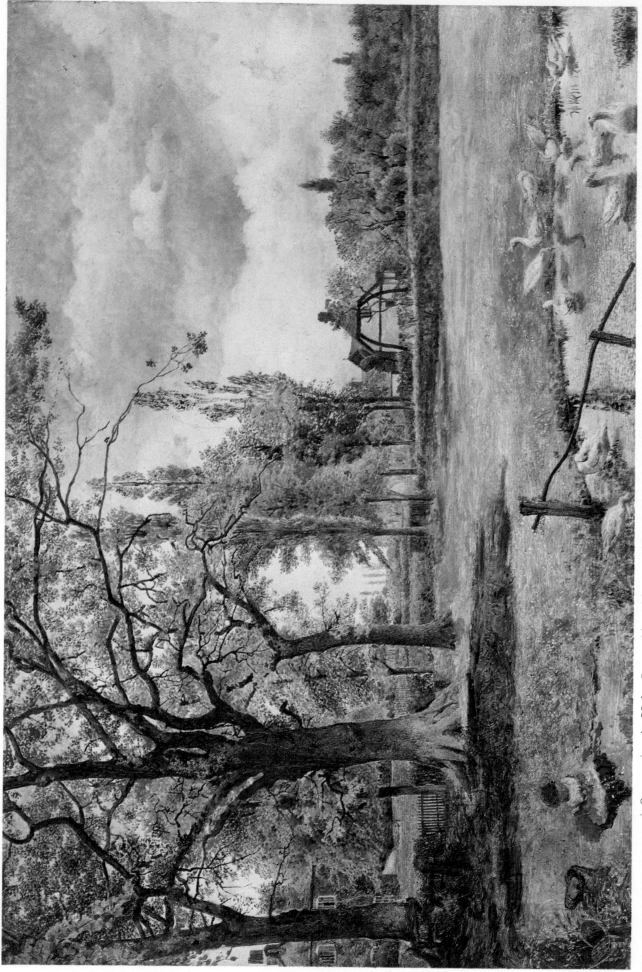

24. WILLIAM DAVIS (1812–73): *At Hale, Lancashire.* About 1860. Liverpool, Walker Art Gallery

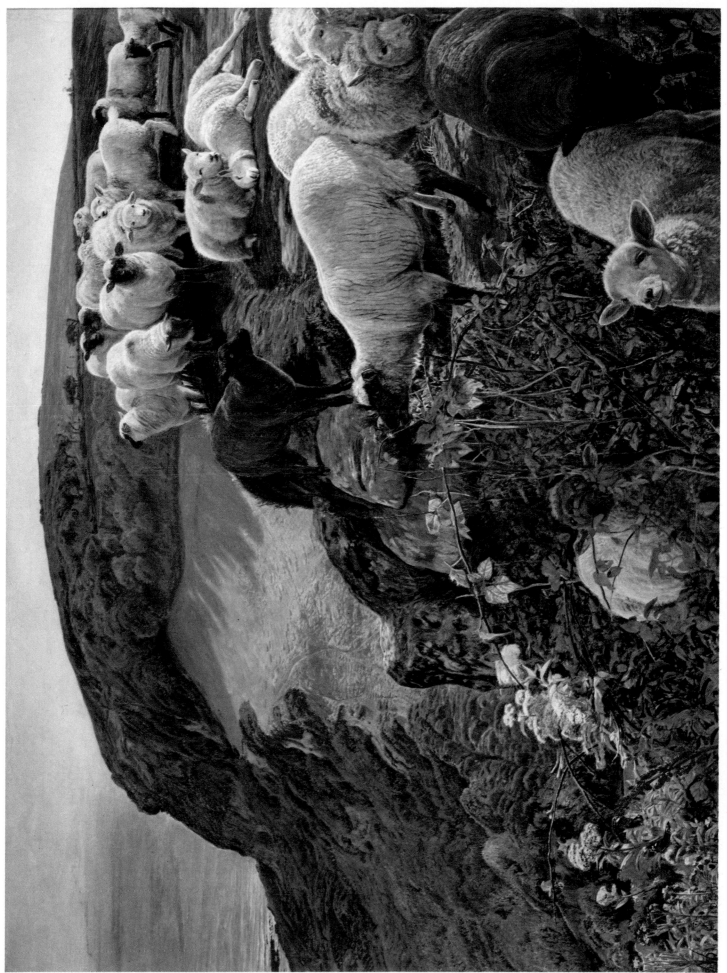

25. WILLIAM HOLMAN HUNT (1827–1910): *Our English Coasts*. 1852. London, Tate Gallery

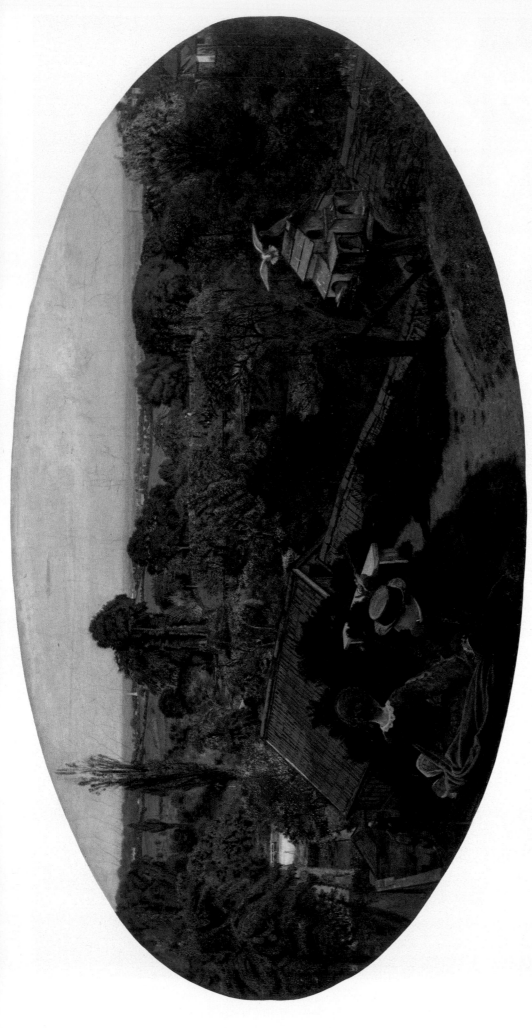

26. FORD MADOX BROWN (1821–93): *An English Autumn Afternoon.* 1852–4. Birmingham City Museums and Art Gallery

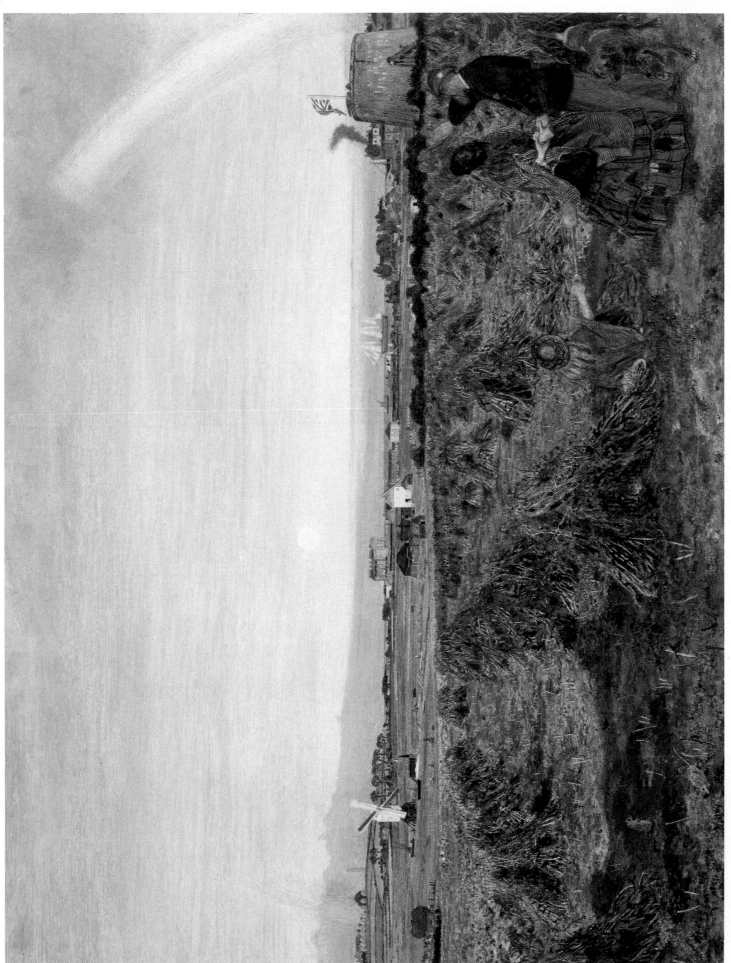

27. FORD MADOX BROWN (1821–93): *Walton-on-the-Naze*. 1859–60. Birmingham City Museums and Art Gallery

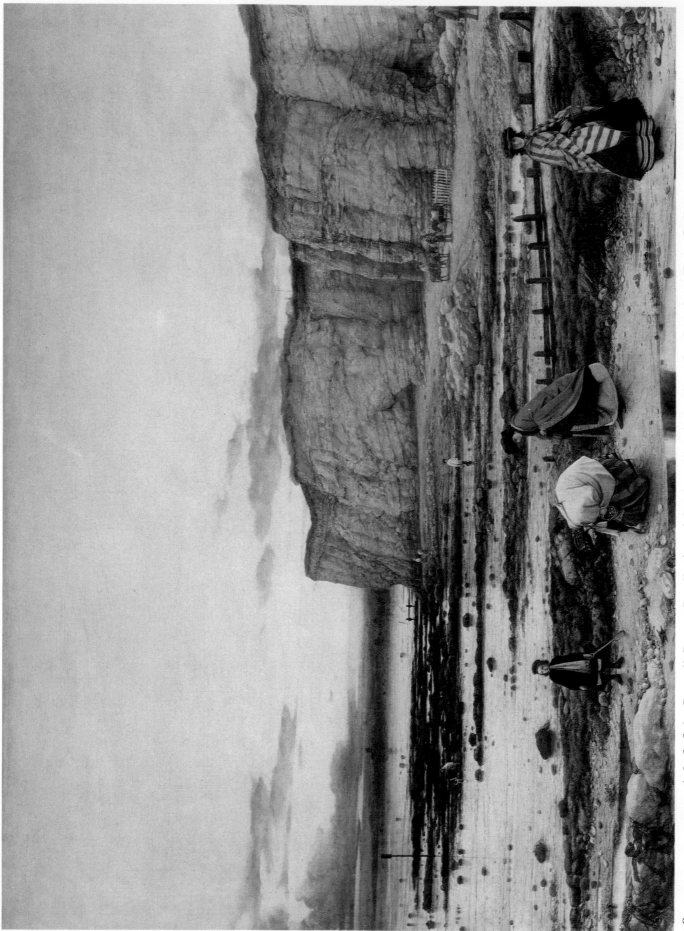

28. WILLIAM DYCE (1806–64) : *Pegwell Bay, a Recollection of October 5th, 1858*. 1859–60. London, Tate Gallery

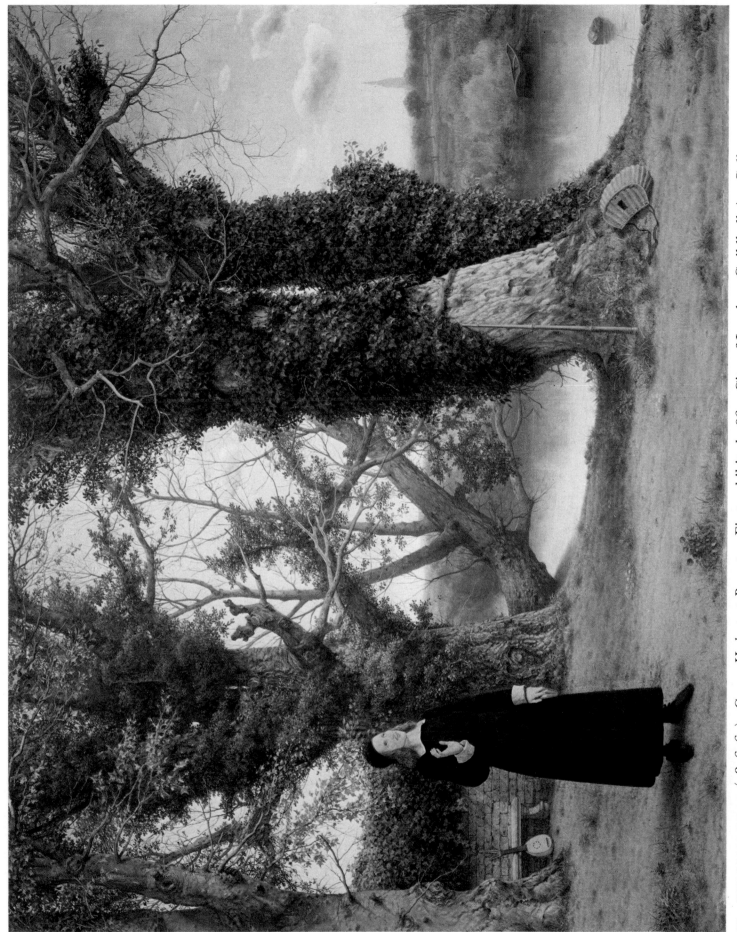

29. WILLIAM DYCE (1806–64): *George Herbert at Bemerton*. First exhibited 1861. City of London, Guildhall Art Gallery

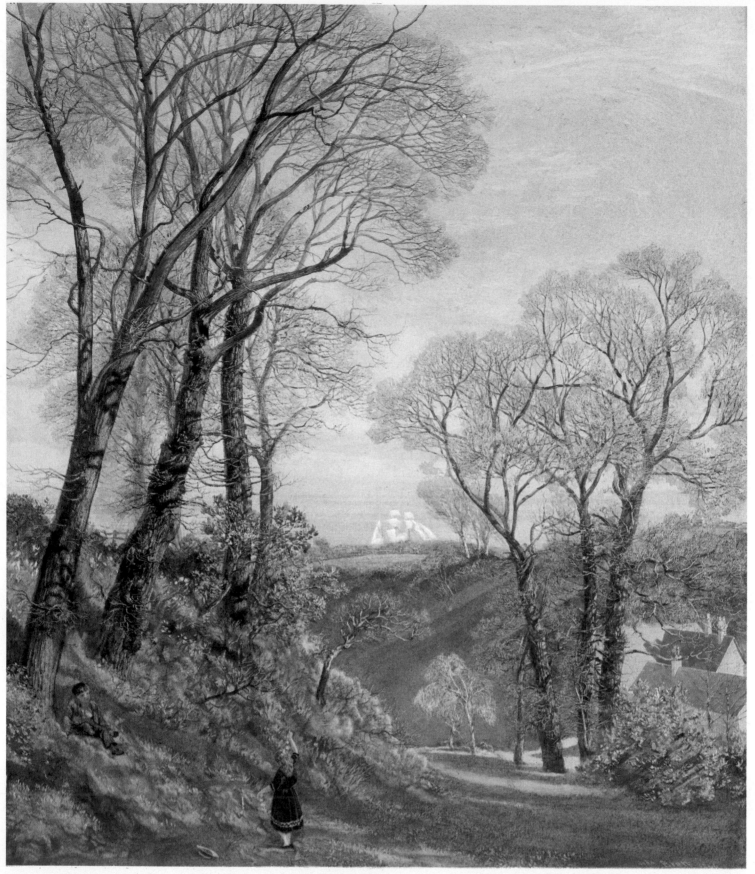

30. JOHN BRETT (1830–1902): *February in the Isle of Wight.* 1866. Birmingham City Museums and Art Gallery

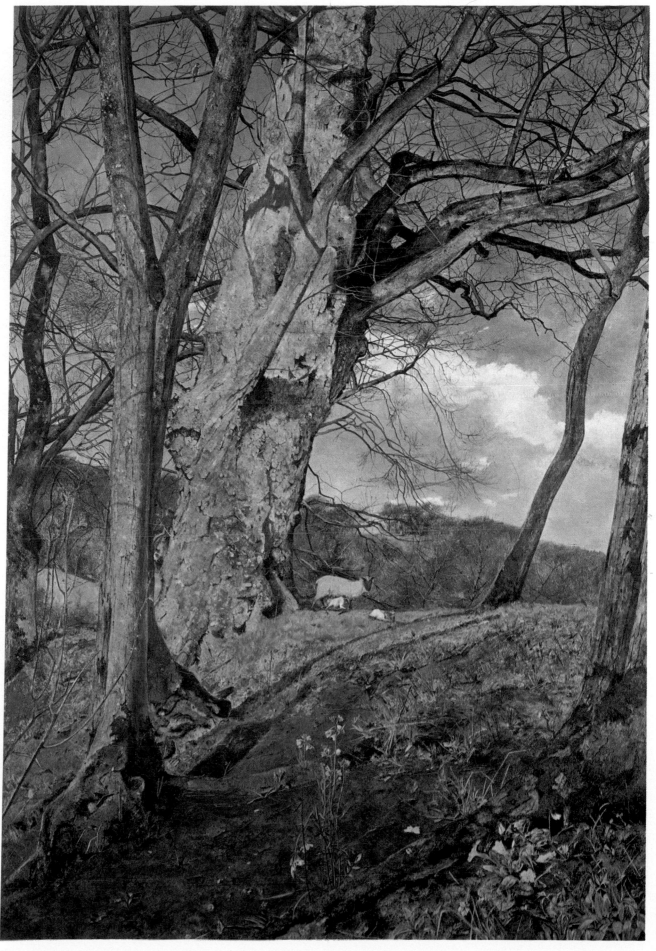

31. JOHN WILLIAM INCHBOLD (1830–88): *In Early Spring*. About 1870. Oxford, Ashmolean Museum

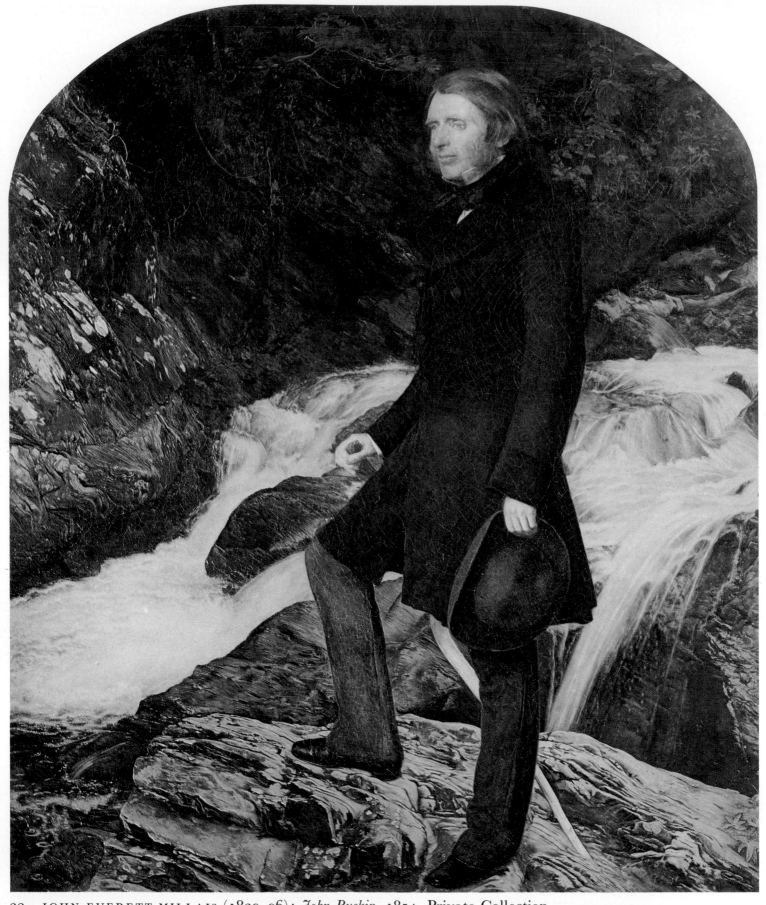

32. JOHN EVERETT MILLAIS (1829–96): *John Ruskin*. 1854. Private Collection

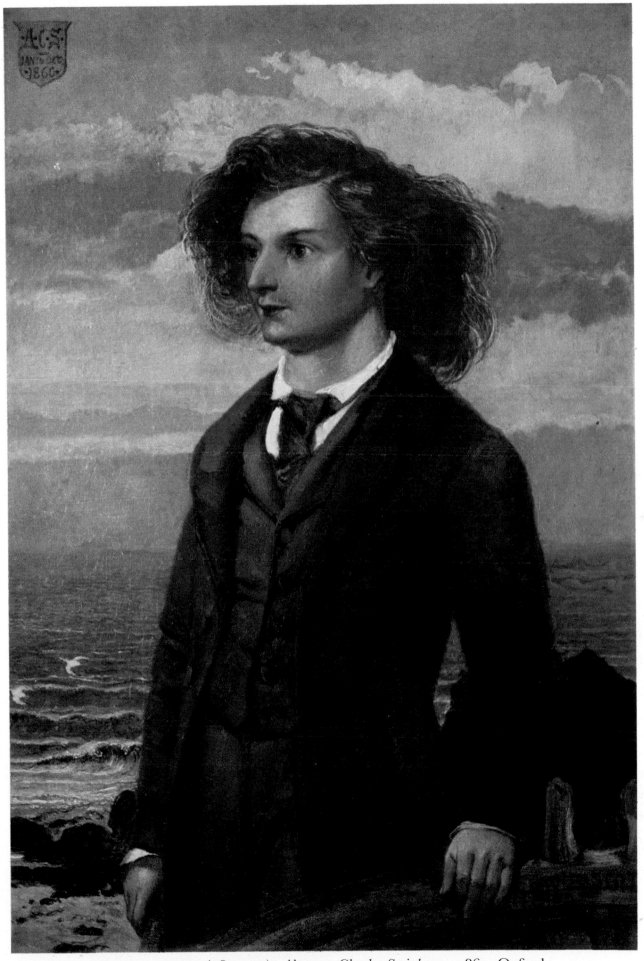

33. WILLIAM BELL SCOTT (1811–90): *Algernon Charles Swinburne*. 1860. Oxford,
Balliol College

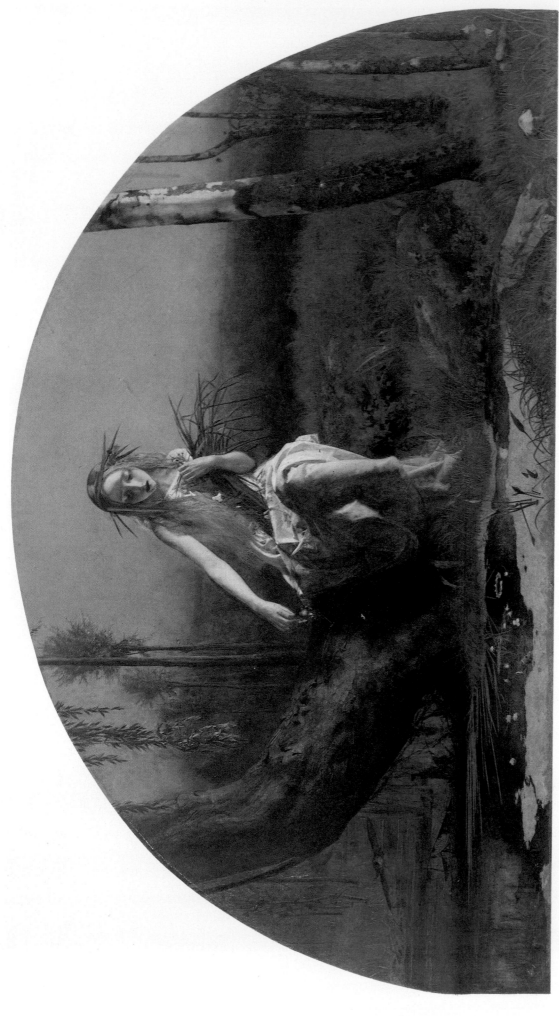

34. ARTHUR HUGHES (1830–1915): *Ophelia*. 1852. Manchester City Art Gallery

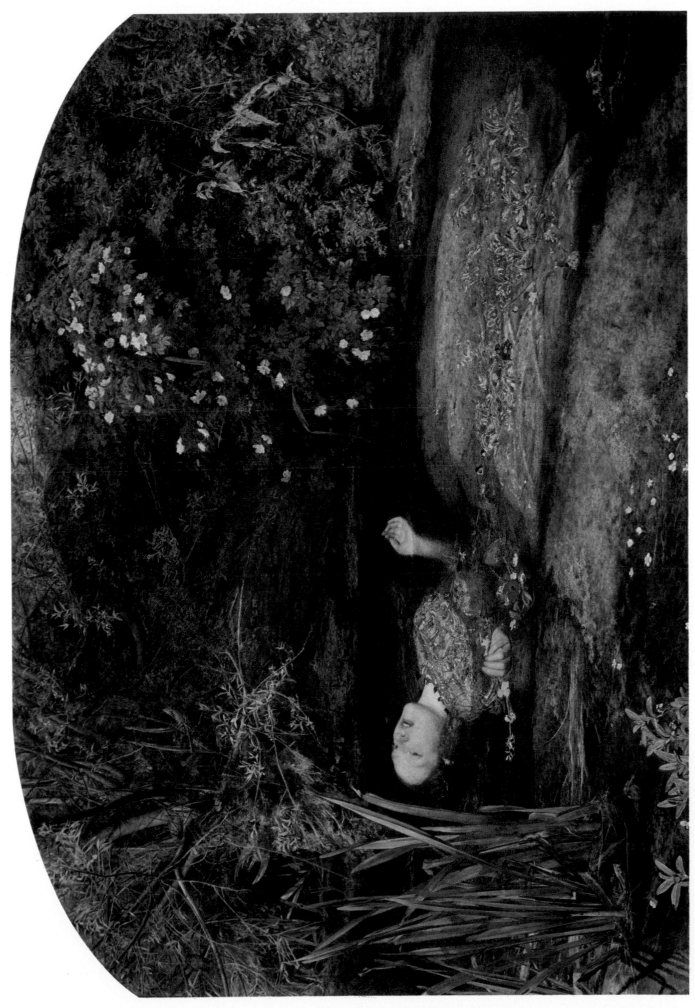

35. JOHN EVERETT MILLAIS (1829–96): *Ophelia*. 1851–2. London, Tate Gallery

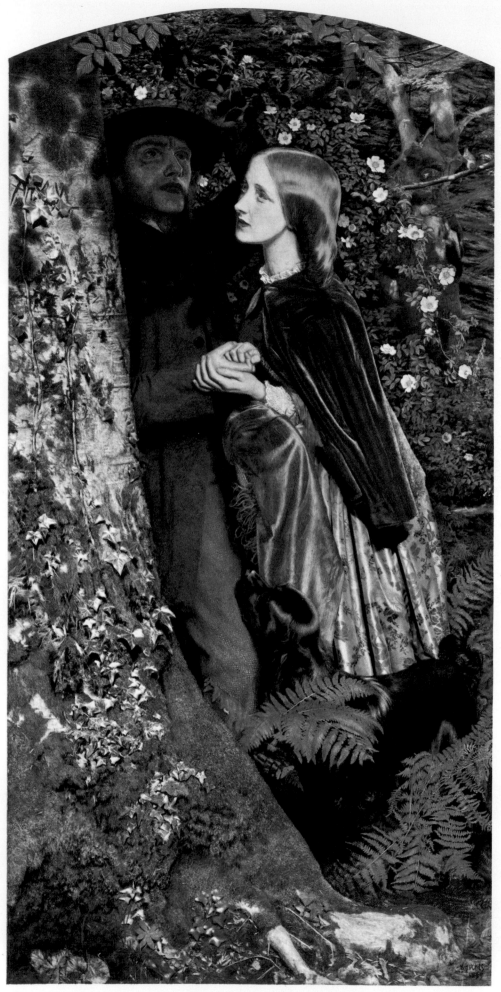

36. ARTHUR HUGHES (1830–1915): *The Long Engagement*. 1859.
Birmingham City Museums and Art Gallery

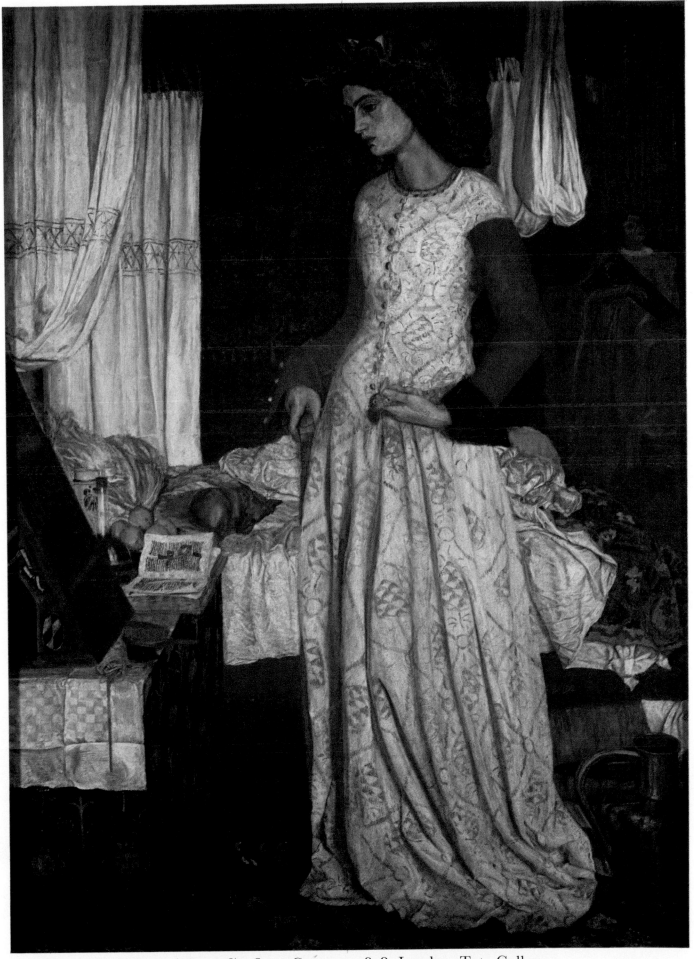

37. WILLIAM MORRIS (1834–96): *Queen Guenevere*. 1858. London, Tate Gallery

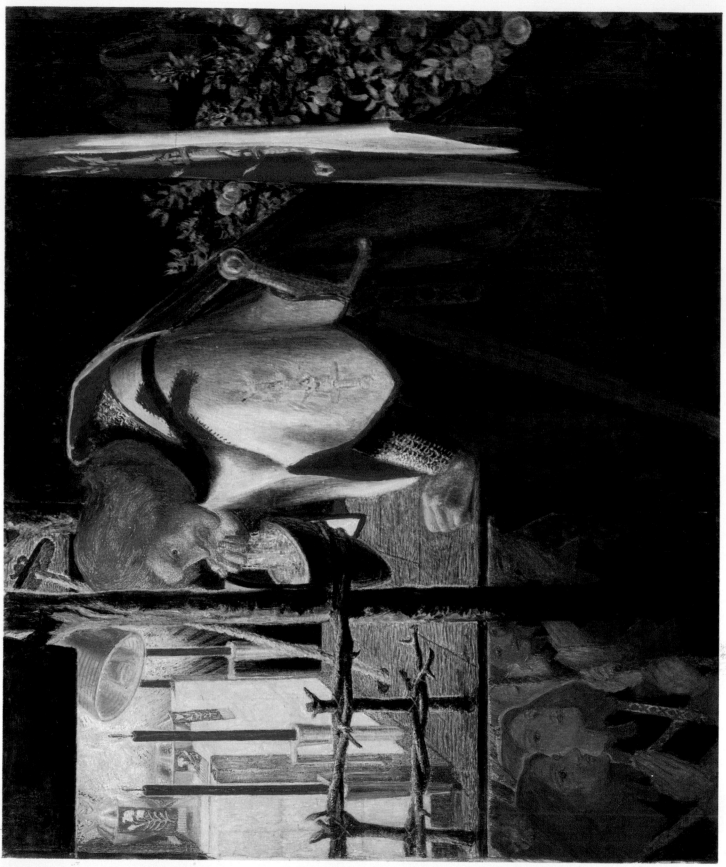

38. DANTE GABRIEL ROSSETTI (1828–82) : *Sir Galahad at the Ruined Chapel*. 1859. Birmingham City Museums and Art Gallery

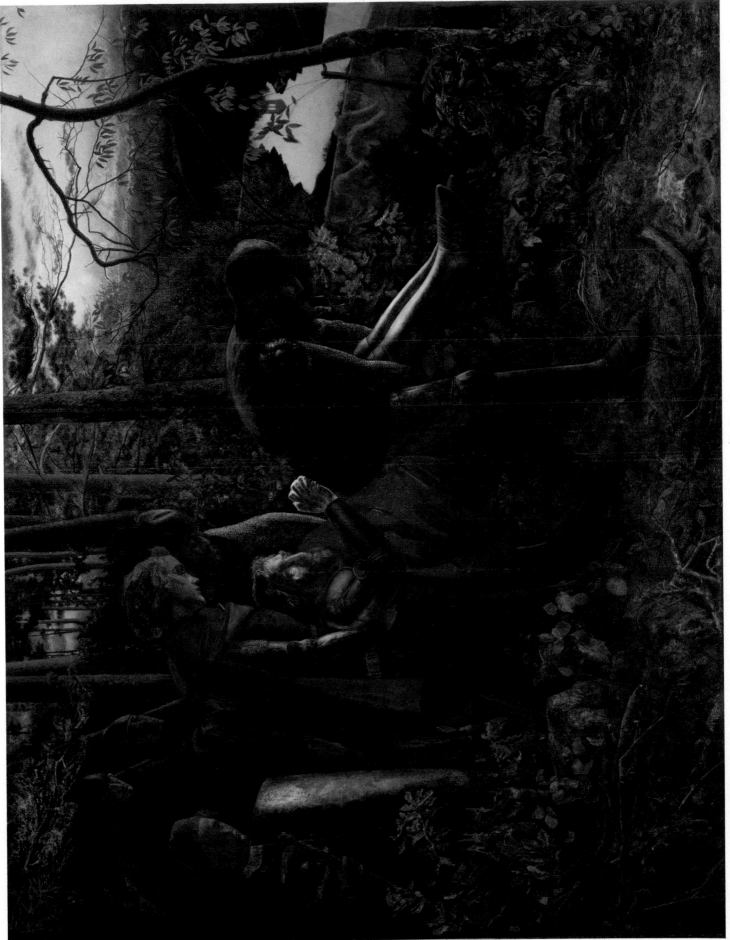

39. ARTHUR HUGHES (1830–1915): *The Knight of the Sun*. 1860. Private Collection

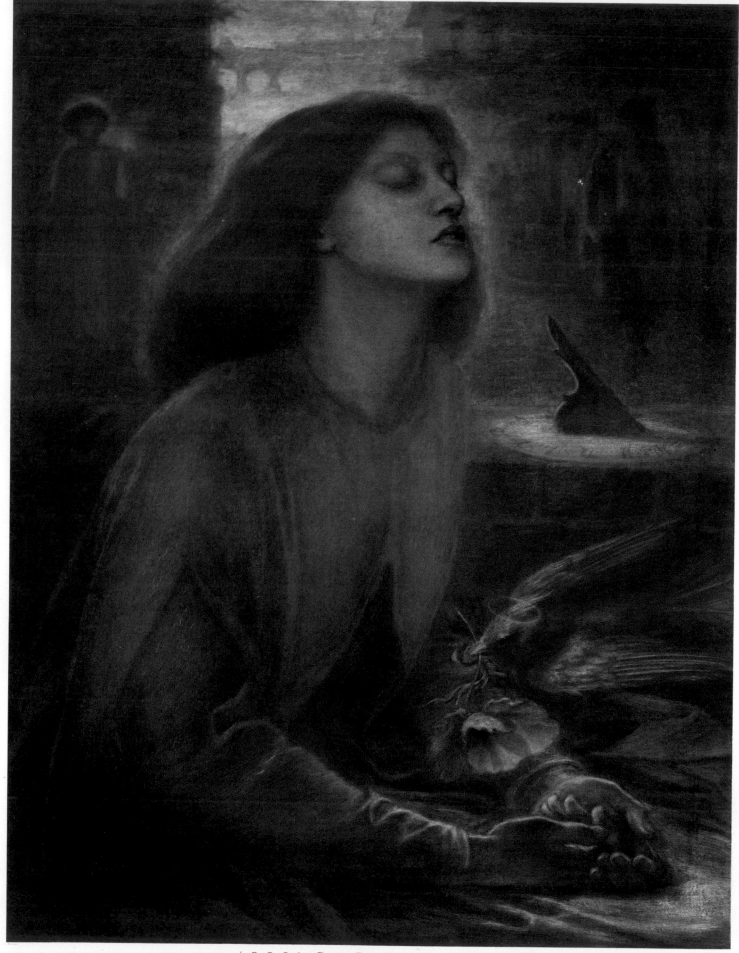

40. DANTE GABRIEL ROSSETTI (1828–82): *Beata Beatrix*. About 1863. London, Tate Gallery

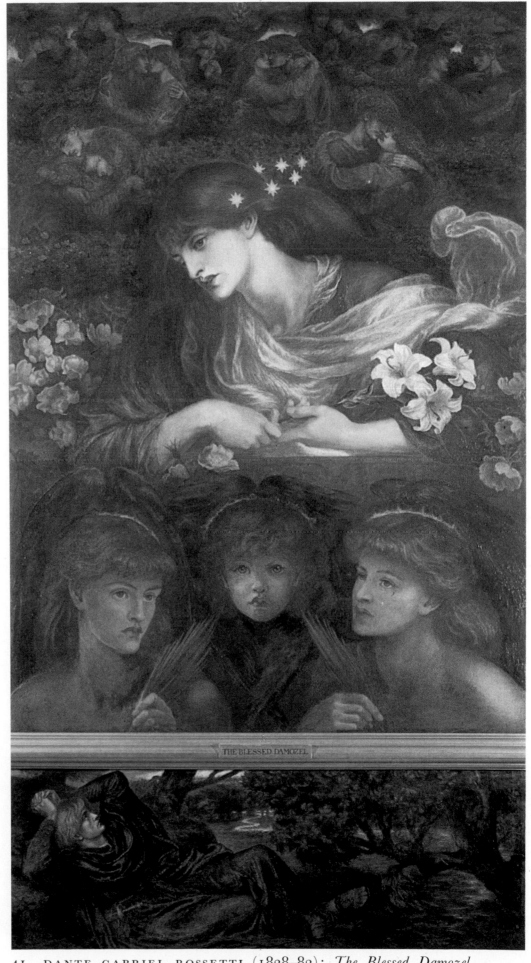

41. DANTE GABRIEL ROSSETTI (1828–82): *The Blessed Damozel*.
1871–7. Cambridge, Massachusetts, Fogg Art Museum

42. JOHN MELLHUISH STRUDWICK (1849–1935): *The Gentle Music of a Bygone Day.* 1890.
Private Collection

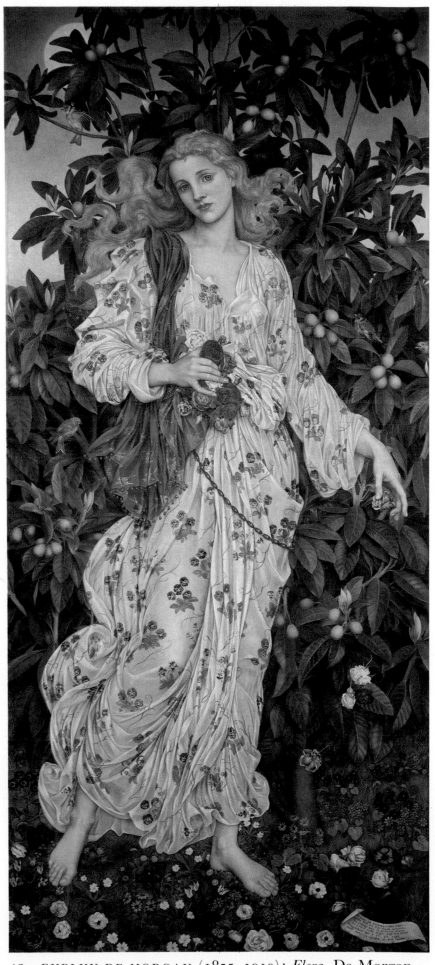

43. EVELYN DE MORGAN (1855–1919): *Flora*. De Morgan
Foundation

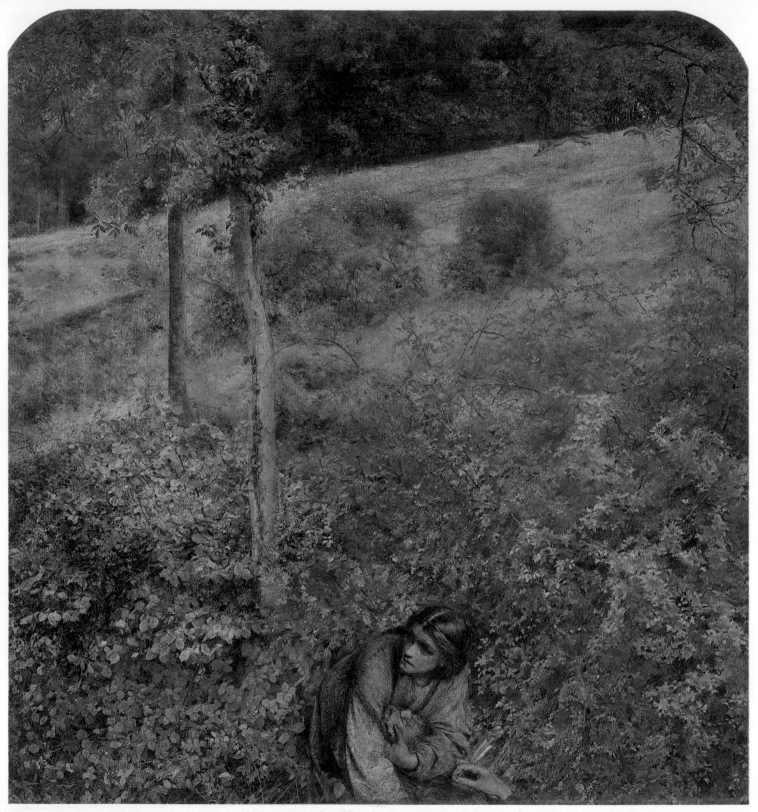

44. WILLIAM LINDSAY WINDUS (1823–1907): *The Outlaw*. 1861. Manchester City Art Gallery

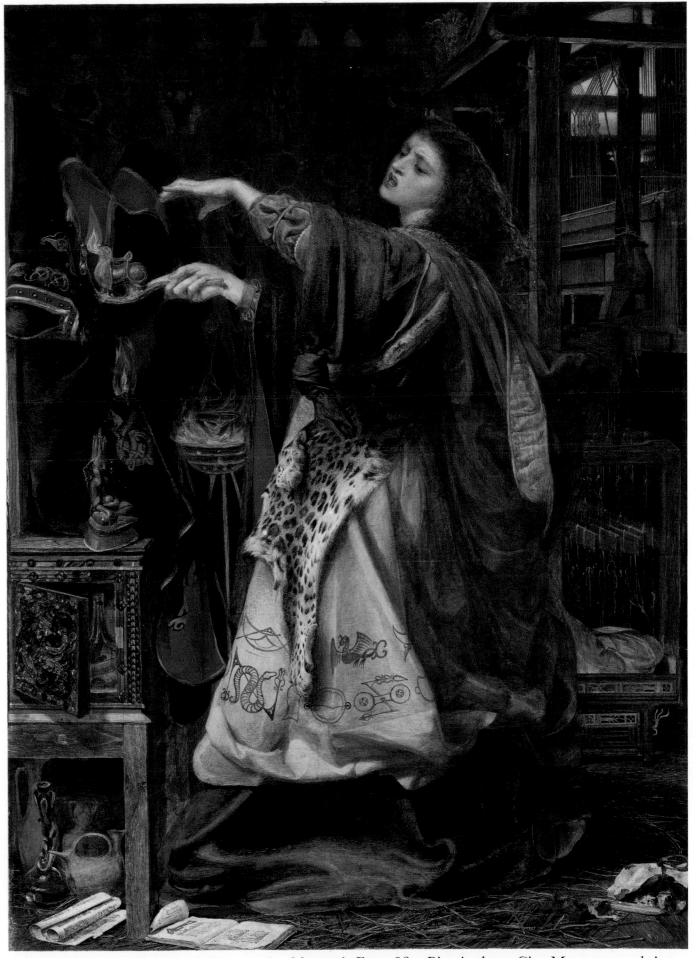

45. FREDERICK SANDYS (1832–1904): *Morgan-le-Fay*. 1864. Birmingham City Museums and Art Gallery

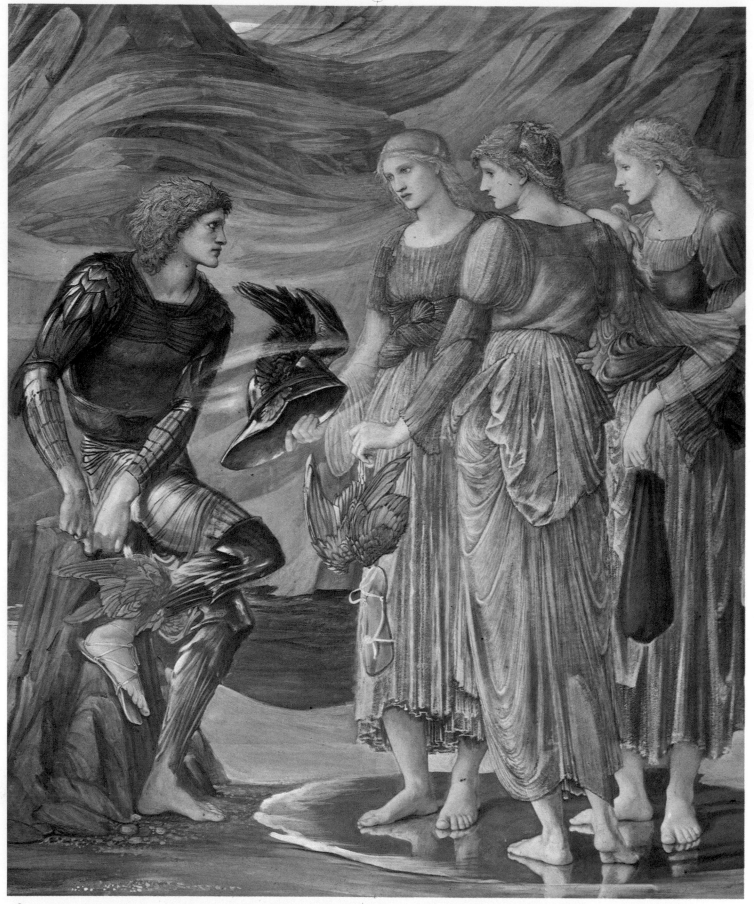

46. EDWARD COLEY BURNE-JONES (1833–98): *The Arming of Perseus*. 1877. Southampton Art Gallery

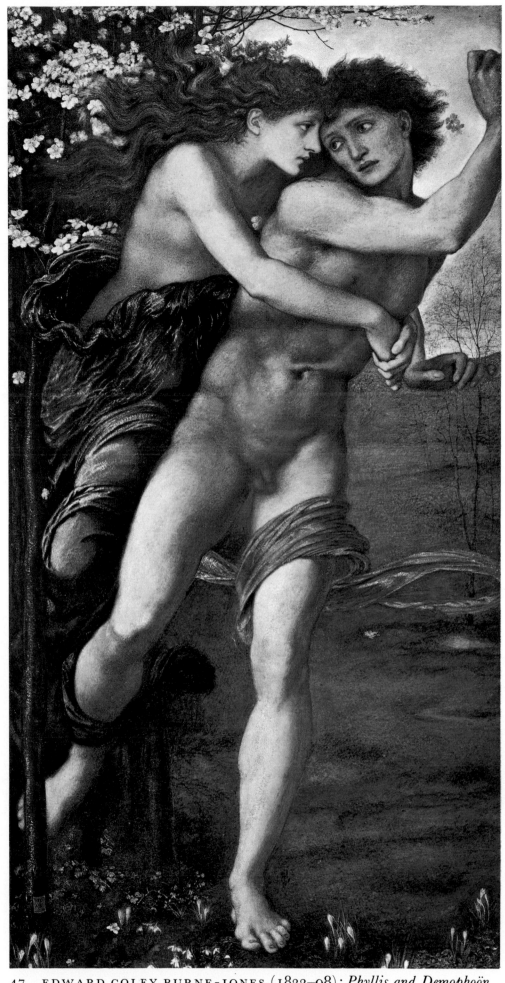

47. EDWARD COLEY BURNE-JONES (1833–98): *Phyllis and Demophoön.*
1870. Birmingham City Museums and Art Gallery

48. JOHN BYAM SHAW (1872–1919): *The Boer War*. 1901. Birmingham City Museums and Art Gallery